The
HIDDEN
HISTORY
of
EAST
TENNESSEE

JOE GUY

THE
History
PRESS

Published by The History Press
Charleston, SC 29403
www.historypress.net

Copyright © 2008 by Joe Guy
All rights reserved

Cover design by Marshall Hudson.
First published 2008
Second printing 2009
Third printing 2010
Fourth printing 2011
Fifth printing 2011
Sixth printing 2013

Manufactured in the United States

ISBN 978.1.59629.510.0

Library of Congress Cataloging-in-Publication Data
Guy, Joe D.
The hidden history of East Tennessee / Joe D. Guy.
p. cm.
ISBN 978-1-59629-510-0
1. Tennessee, East--History--Anecdotes. I. Title.
F442.1.G89 2008
976.8--dc22
2008025713

For Stephanie

CONTENTS

CONTENTS

INTRODUCTION

History, and the stories that make up history, have long interested me, especially those from the place I call home: Southeast Tennessee. I am fortunate to have a job with almost unlimited access to people, their stories and historical records. Sometimes I feel like the main character in the *National Treasure* movies, except on a smaller scale. Local and regional history is like a treasure hunt, with clues and symbols that lead to really great stories. So if you like history and you like stories, then this book is for you. As I have said before, I have tried to be as factually true to the historical record as possible, but not knowing all the facts has not always kept me from writing either. I hope you will enjoy these stories, visit the places associated with them and perhaps even dig deeper to find more facts and deeper truths.

It is important to note some people who made this book possible. So many people bring me stories and ideas that it is impossible to mention them all, but a few stand out: Patsy Duckworth, Bill Akins and Kenneth Langley with the McMinn County Historical Society; Linda Caldwell with the Tennessee Overhill Heritage Association; and County Mayor John Gentry. I also want to mention Hubert and Bertha Davis of Monroe County's Coker Creek Community, who were so kind to point me to Goldman Bryson's grave as well as to add more information to his

story. Of course, I want to thank some of the editors whose newspapers have been so great as to carry my stories to thousands of readers over the past few years: the *Daily Post Athenian*, the *Polk County News*, the *Monroe County Advocate and Skyway News*, the *Rhea County Herald* and the *Bradley News Weekly*. It was wonderful to develop a relationship with such a fine publisher as The History Press for the publication of my McMinn County book, and I was even more humbled when they showed interest in this book containing stories about East Tennessee. Publisher Magan Lyons and Commissioning Editor John Wilkinson, along with the rest of the editing, production, design and marketing staff, are true professionals who would make any author happy.

Most of all, I want to thank my beautiful wife, Stephanie. She has ridden and walked hundreds of miles, waded creeks and crossed mountains, sometimes just to take a single picture or to help me find some obscure piece of a story. All the while she has been my advisor, business manager, hiking partner and photo processor; for our boys she's a mom, taxi and little league manager. And when we all go to sleep at night, she goes to work at her full-time job as a professional mental health specialist. She's the best, and I could not do this without her.

PEOPLE AND PLACES

The historical record, as well as the stories and legends that intertwine with history, have essentially two elements: the place where things happened and the people who were involved. While people pass away, places remain. I have long been fascinated by places: old roads, old homeplaces, places where people lived and died, committed crimes, stood up for what they believed was right and how people reacted to situations. All these things gave birth to the significant events that shape our regional history.

Federal Road

The valleys of Southeast Tennessee generally run northeast to southwest along the fringes of the Appalachians, and for centuries these valleys have forced travelers, wildlife and even creeks to move along at a "slant." It is entirely impossible to travel either due north or due south without eventually having to cross a mountain. Even our modern interstate follows the route of the valleys in order to make road construction and travel easier to accommodate. The valleys have always ruled, determining both movement and settlement for years upon years.

The present Old Federal Road through Monroe, McMinn and Polk Counties follows much of the original course of the road built by the Cherokees in 1804. This road is considered by many historians also to follow the course of the centuries-old Great Indian Warpath. *Photo by Stephanie Guy.*

Yes, for centuries it has been so. For more than a thousand years, the herds of deer, elk and buffalo that migrated up and down the valley walked the same "slanted" path. The animals were followed by the Native American hunters, who then used the same paths to trade and make war on enemy tribes. The main course of this valley path could be followed northeast into what is today Virginia and Kentucky, and south and southwest into present-day Alabama, Georgia and Florida. By the 1700s it was referred to as the Great Indian Warpath. Over the centuries, the trail moved from ridge to nearby meadow and back again, depending upon vegetation, flooding creeks, occasional "spur" trails and changing migration routes. Essentially, it remained true to its course, likely staying within a few hundred feet.

As Southeast Tennessee was being settled in the early 1800s, the trail had turned into a wagon road north of Knoxville, but through the Cherokee country it remained a trail. Due to the mountains to the east, the easiest passage for mail routes and coastal markets was toward the south, but the Cherokee and other tribes stood in the way.

In October of 1805, a treaty was conducted at Tellico Blockhouse on the Little Tennessee River. In Article 2 of the treaty, a new road was addressed: "The mail of the United States is ordered to be carried from Knoxville to New Orleans, through the Cherokee, Creek and Choctaw countries; the Cherokees agree that that the citizens of the United States shall have, so as it passes through their country, the free and unmolested use of a road leading from Tellico to Tombigbee, to be laid out the best way."

The Cherokee, having already adopted white culture, were contracted to build the road. Since the old warriors' path was already there, it stands to reason that the simple solution was to widen and improve the old trail into a "modern" wagon road. This was done, and soon herds of swine and cattle, wagonloads of wares and travelers and the occasional mail carrier were passing over the dusty road. Inns and taverns began to appear, along with a farmhouse here and there, and before long the road became a well-known landmark, and was known as the Federal Road.

For many years, the road serviced travelers throughout East Tennessee, although it was not always a safe route. Outliers and thieves were known to lie in wait along the dark hollows and forests the road passed through. In my own family, it is recorded that a distant grandfather, one Johann Georg Burger, a German immigrant who had established a farm along a nearby creek, left his family with a wagonload of goods to sell in Georgia, most likely traveling south down the Federal Road. But he never returned, and it was believed that he was waylaid by robbers somewhere along his way.

As time passed and settlements shifted, new roads were built, and the passage came to be referred to as the "Old" Federal Road. Today, modern highways such as U.S. 411 either run parallel or sometimes follow the old roadway. Other portions of the old road still remain and are in use as secondary roads. Some roads even maintain the name of "Old Federal" in several counties in Southeast Tennessee and North Georgia. In some places, unimproved portions of the old wagon road are still visible along an occasional field or as it disappears into a quiet stand of trees. For most, the Old Federal Road is simply a name that appears on a map.

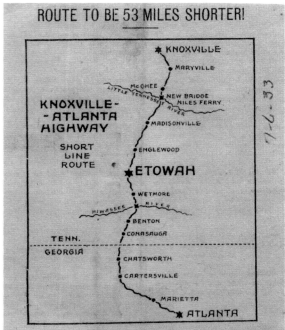

ROUTE TO BE 53 MILES SHORTER!

KNOXVILLE–
–ATLANTA
HIGHWAY

SHORT
LINE
ROUTE

TENN.
GEORGIA

KNOXVILLE
MARYVILLE
McGHEE
LITTLE TENNESSEE
NEW BRIDGE
NILES FERRY
RIVER
MADISONVILLE
ENGLEWOOD
★ETOWAH
WETMORE
RIVER
HIWASSEE
BENTON
CONASAUGA
CHATSWORTH
CARTERSVILLE
MARIETTA
★ ATLANTA

Above shows the cut of the Knoxville-Atlanta shortline highway, with the Etowah-Benton link, the opening of which was celebrated with a mammoth celebration at Benton Tuesday. With a few miles under construction between Niles Ferry and Madisonville, the highway is all concreted and hard surfaced from Knoxville to the Georgia line. When the entire road is con-creted, the line will be a perfect stretch from Knoxville to Atlanta, a route 53 miles shorter than any other route between the two points.

When U.S. Highway 411 was constructed through Southeast Tennessee in the 1930s, portions of the highway either paralleled or followed the route of the Old Federal Road. *Courtesy McMinn County Historical Society.*

Perhaps the bones of Johann Georg Burger still lie in an unmarked grave on some quiet spot on the old road, along with the memories of buffalo and native footsteps, of hog herders and wagon wheels, paved with time and the use of a thousand years of travel up and down the slanted valley.

The Day the Women Ruled in Decatur

Female citizens have played an important part in the history of McMinn County and its surrounding area. Niota is well-known for having an all-female city council at one time, those ladies enjoying a feature on *Good Morning America* in the late 1980s.

Maybe it is the effects of our latent Cherokee heritage. The Cherokee was a culture where women played a large role in society long before white men saw the wisdom in allowing equal rights to their better halves. The Cherokee even traced their lineage through their mothers' side of the family rather than their fathers', giving rise to such misunderstood legends as the Indian "Princess" Nancy Ward.

Two extremes of the leadership skills of our county's women were recently discovered in the archives of the McMinn Historical Society, in two separate editorials from some old edition of the *Athens Post*. The first appeared in 1922 in an editorial featuring the town of Englewood. The writer went on to sing the praises of the "gem of the Unakas," speaking highly of its location near Starr Mountain's White Cliff Springs and the rich soil in the "red knobs" of Liberty Hill. But in regard to the town's leadership, the writer had the following to say about the "splendid little city of Englewood":

> *Her women, as well as her men, are wide awake business people. The women of Englewood are playing an important part in its development; a woman is president of the Eureka Hosiery Mill; a woman, Miss Sallie Smith, is assistant cashier of the Bank of Englewood, and is also a member of the Board of Directors; a woman, Mrs. Heath, runs the principal hotel; a woman, Mrs. Tallent, runs a first class boarding house; and women, Mrs. Chestnut and daughters Misses Grace and Nannie, run a 600 acre farm.*

In taking a tour of the Englewood Textile Museum and Company Store today, it is readily apparent that the largely female-staffed Community

Action Group of Englewood (CAGE) continues the tradition of strong leadership by the women in Englewood.

The second editorial, taken out of the same paper, was a reprint from an edition several decades earlier, and shows a quite different instance of female leadership. Writing in the late 1860s, the editorial spoke of a letter relating a particular instance in Decatur, in nearby Meigs County:

"The vending of 'Ball-face' [a derogatory term for liquor] in our little town having become a nuisance to all civil people, the ladies assembled yesterday, in broad daylight, and poured all the liquor out of the barrels, bottles, etc. of the grocery and put up a notice that any more brought here will meet with the same fate."

Pretty strong action by the town's women, especially in the mid-nineteenth century. Still, even when most women could not own property and certainly could not vote, the ladies in 1860s' Decatur were far from powerless. When liquor flooded the streets that day, one can imagine many men who cowered in dark corners, dreading the tongue lashing they would likely receive when they got home.

The writer of the *Post*'s editorial supported the act in no uncertain terms when he added, "We heartily approve of the act of our fair friends of Decatur, and trust that their example will be followed by the ladies of other towns and villages. Tipping houses are not only a nuisance to a community, but smell rankly to Heaven."

A Bloody Day at Lenderman's Store

The sign on the old building on Highway 68 in Monroe County's Coker Creek Community simply reads "Trading Post." The gray sided building with the steep tin roof, an old relic from days long since passed, attracts much attention from those who pass by. Ironically, the building was at one time a country store and post office, still

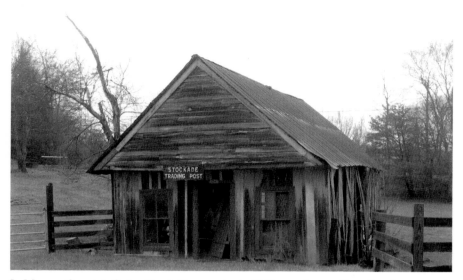

In Monroe County's Coker Creek Community in 1918, storekeeper Dave Lenderman and his brother Luther killed both Bill Garland and his son Obe when they came looking for trouble. The Lendermans were known as good neighbors and friendly farmers, but would not be intimidated by the Garlands. *Photo by Stephanie Guy.*

remembered by some as being owned by Dave Lenderman, and that was a century ago. The stillness of the fading building today betrays the violence that took place there in 1918, a bloody encounter at the old store that left two men dead.

Dave Lenderman is recalled as being an easygoing man, not prone to violence, but not one to be pushed too far either. Typical of a general store owner in Appalachia, he worked hard to provide a good business in his community, and guarded his store as his means of supporting his family.

Bill and Obe Garland were of the same community, but of a much different breed. Bill, the father, and Obe, the son, drifted back and forth over the mountains between Coker Creek in Tennessee and Murphy in North Carolina. They were known to steal anything they came across, were nearly always drunk with "shine" and would just as soon shoot a man as look at him. Both were big men, and if they were alive today

they might have been called "tush hogs" or "bullies." Few people ever confronted the shotgun-wielding Garlands and lived to tell about it.

On a fall day in 1918, the father and son had drifted into Coker Creek, some say looking for trouble. One story goes that Bill was angry at Lenderman for refusing to sell him some corn or sugar to make moonshine, due to the fact that Bill had not paid a past debt. Bill went into Lenderman's Store, a common gathering place, and without warning began firing his shotgun. By the time he calmly walked out, the only injury was to Dave Lenderman's glass display counter. Or so it seemed at the time.

Bill and Obe camped nearby that night and continued drinking. The following day, it was Obe who walked into Lenderman's Store with a shotgun in his hands. Perhaps he'd grown overconfident from the moonshine in his veins, or maybe from his father's bragging all night long. Dave Lenderman watched calmly as Obe ambled around the store. Dave's brother, Luther, was sitting near the potbelly stove.

Obe approached Dave, saying he wanted to mail a letter. Dave took the paper from Obe's hand, and as he tossed the envelope into a nearby mail sack Obe swung the shotgun around and fired. A buckshot pellet passed so close to Dave that it cut though his overall strap. Whether Obe Garland meant to kill Dave or only scare him is left to history, because he'd made a tragic mistake: his shotgun was now empty. Expecting trouble, Dave had carried a pistol with him to the store that day, which he drew and fired point-blank into Obe's body, killing him. Knowing Bill would be nearby, Luther grabbed his own shotgun.

Indeed, Bill had started walking toward Lenderman's when he heard the shots. He strolled up to the door, and for some reason put down his shotgun. His huge body crowded the door as he peered in and saw his son's body on the floor. He looked at Dave and said, "Dave, you done shot my boy."

"I had to, Bill," Dave calmly answered.

Bill stepped forward with a knife in his hand. Dave raised the pistol and fired several shots. Bill halted and then retreated outside and around the rear of the building, where Luther waited. Bill stumbled to the side

of the store and leaned his head on the gray wood. Luther took aim and shot him through the neck. Days later, both Bill and Obe Garland were buried on a nearby mountain in the same grave. They would never be a cause for fear again.

In those backwoods days of Coker Creek, a man's property was sacred and he had a God-given right to protect it. Neither Dave nor Luther Lenderman was ever charged with a crime. And still the old store building remains, like a great gray monument to a violent rural encounter settled with pistols and shotguns.

The Weatherman of East Tennessee

In 1882, the National Weather Service was being rocked with scandal. At the time, the service was a part of the Army Signal Corps, and was held in disdain by the general public because of its inability to correctly predict the weather. An effort was made to correct the Weather Service's many faults by recruiting college-trained personnel who were personally recommended by their college presidents. One such young recruit, named Isaac Monroe Cline, came from Hiwassee College in Madisonville.

Born in Madisonville in 1861, Isaac Cline grew up in the Bat Creek community. He was an overly intelligent boy who read incessantly, and at the young age of sixteen enrolled in Hiwassee College. He eventually earned a master's degree, and considered becoming either a minister or a lawyer. But he was a rather big storyteller, and he made up his mind to "seek some field where I could tell big stories and tell the truth."

Cline eagerly accepted the offer to work for the Weather Service, and he was commissioned into the army to pursue meteorology. The training was intense, and Cline soon found himself assigned to a post in Little Rock, Arkansas, to study the relationship between weather and the Rocky Mountains.

While at Little Rock, Cline had the opportunity to invest in some new technology: the telephone. But Cline later stated that "in my opinion, the telephone might be used successfully in talking over distances of one or two miles but that would be the limit. I could not visualize that within my lifetime telephone conversations would be carried on successfully all over the world. The boys who bought stock and held it became wealthy in a few years."

Cline continued his education, and in 1885 received his medical diploma. He was promoted to take over the operations of the weather station in Fort Concho, Texas, which was soon moved to Abilene. There he met and married Ms. Cora May Ballew. In 1889, Cline, along with his brother Joseph, took over the weather station at Galveston. For Isaac Cline, it would be a fateful decision.

By 1900, Galveston had a population of thirty-seven thousand and was a prosperous island city on the Texas Coast. In early September of that year, Isaac Cline noted a storm that had begun to form in the Gulf of Mexico that seemed to be heading for the Galveston area. But Cline was not concerned. He even went so far as to write two stories in the *Galveston News* saying he did not believe any hurricane to be a danger to the city. The storm hit on September 8, and would eventually be the worst hurricane ever to hit Texas, effectively destroying Galveston and killing thousands. Isaac Cline, as head of the weather station, was directly involved in the hurricane warning. Some say he was a hero whose warnings saved many lives. Others tell a different story.

In the book *Isaac's Storm* by Erik Larson, the story is told that Cline failed to realize the true strength of the hurricane as it approached Galveston. As the fury of the storm increased, Joseph finally persuaded Isaac to raise the hurricane warning flag, but it was too late. Isaac's own pregnant wife was among the dead, killed by the storm surge.

Although the Weather Service hailed Isaac as a hero, he was soon transferred to New Orleans, and Joseph was sent to Puerto Rico. It was said that Joseph never forgave his brother for the failure at Galveston. Isaac eventually retired in 1935. He operated an art store in New Orleans until his death in 1955.

Cline remains an icon in the Weather Service, and earned acclaim for river forecasting as well as weather forecasting. From his experience with hurricanes and other tidal phenomena, Cline published a book, *Tropical Cyclones*. Later, he penned his own autobiography, *Storms, Floods, and Sunshine*.

Perhaps it was his fateful experience in Galveston that pushed Cline deeper into the study of tropical storms. His warnings regarding the potential Mississippi River Flood of 1903 are credited with saving countless lives and property. It is said that New Orleans shopkeepers had so much faith in Cline's predictions that they would either open or close their shops based upon whether they observed Cline strolling down the street with an umbrella. His weather predictions would always ring true, and he is credited with giving the Weather Service the dependability it enjoys today. Each year, the National Weather Service presents an annual Isaac Cline Award for meritorious weather-related service, in recognition of the weather pioneer from East Tennessee.

The Overmountain Man

When Isaac Lane died on November 9, 1851, the long life of a remarkable man ended. At the age of ninety-two, Lane had been a frontier scout, an Indian fighter and a Patriot. He'd hunted down murdering Tories, fought alongside John Sevier and helped defeat a British army and the Cherokee War Chief Dragging Canoe.

Born in Virginia in 1759, he was the son of Reverend Tidence and Esther Lane, a well-known Baptist minister on the Southern frontier. Isaac probably first came to the Holston and Watauga settlements in upper East Tennessee from North Carolina with his father around 1778. Here he met John Sevier and soon became a member of the Patriot militia, involved in driving out Tories from the settlements. One Tory

leader, known as Grimes, murdered a settler named Millican and almost killed two others. Isaac was part of a group that pursued Grimes far up into the mountain coves. The Tory escaped, but Isaac Lane would see him again.

In September of 1780, word came to the settlements that a large force of Tories under the British Captain Ferguson was threatening the Holston and Watauga settlements. Isaac was elected lieutenant in Sevier's militia of Overmountain Men, and after assembling at Sycamore Shoals on the Watauga, was soon on the long march into South Carolina. On October 7, the combined force caught Ferguson and defeated him at Kings Mountain. Isaac was in the thickest of the fighting on the south side of the hill under Captain George Russell. One of the British prisoners caught during the battle was the Tory leader Grimes, who Isaac saw hanged not long after fighting had ended.

But the victory was not long enjoyed by the Overmountain Men. Immediately upon their return to Watauga, a trader named Isaac Thomas told of a war party of Cherokee warriors already marching toward the settlements. Again, Lieutenant Isaac Lane followed Sevier as the men were called together and marched south. The Cherokee, under the leadership of the War Chief Dragging Canoe, were encountered at Boyd's Creek in present-day Sevier County. Isaac Lane and John Ward were scouting ahead of the others when Cherokee were seen hiding in the tall grass. Sevier called the men back, and an attack was launched that routed the Indians.

Still fearing an attack, Sevier led his force on southward into the Cherokee towns in present Monroe and McMinn Counties. This was Isaac Lane's first view of the rich lands and streams in the area, and he, along with several other soldiers, made note of the attractiveness of the land.

Returning home, Isaac married Sarah Russell in 1782, who was the daughter of Captain George Russell. Isaac was granted one hundred acres for his militia service in Washington County. They moved to Hawkins County, Tennessee, in 1789, and after the county was divided into Grainger County, Isaac was active in local affairs.

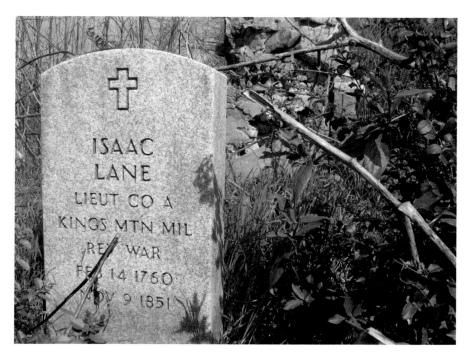

Isaac Lane was one of Tennessee's frontier Patriots, one of the Overmountain Men who served with John Sevier at Kings Mountain, Boyd's Creek and against the British-allied Cherokee. His grave is located in a field near Niota in McMinn County. *Photo by Stephanie Guy.*

When McMinn County was established from Cherokee lands in the Hiwassee Purchase, Isaac and his extended family moved to McMinn County about 1822, returning to the rich lands he'd seen some forty years earlier. They settled on a large plantation on Mouse Creek, where the Lanes were among the largest land owners in the area. The Lane farm was part of what is now the old Burn farm, north of Niota off County Road 319.

Isaac Lane literally saw the births of both the United States and the State of Tennessee, actively participating in their settlement and expansion. At the time of his death, he'd lived long enough to see railroad tracks laid near the small town of Athens over land he'd once known as wilderness, occupied by the Cherokee. He was laid to rest on his farm, only a mile from where the town of Mouse Creek would soon spring up, later to be renamed Niota.

His grave, now overgrown and almost lost in a field north of Niota, has been marked by the Daughters of the American Revolution and recently catalogued by Dennis Stewart as part of the McMinn County Cemetery project.

THE CIVIL WAR

It is not the oft-studied military tactics, the troop movements or the great battles that actually make up the true story of the Civil War in East Tennessee, but long periods of camp life, inactivity, suspicion of neighbors and deeds of frivolity that turned into disaster. The Civil War remains one of the most popular aspects of East Tennessee history.

When the Enemy Was Right Next Door

Outside of the battles at Chattanooga and Fort Sanders in Knoxville, few actual Civil War military engagements were actually fought in Southeast Tennessee. By "military engagements," I mean typical battles, in which troops from two opposing sides line up and have at each other. With most reading material concentrating on the battles and battlefields of the Civil War, it is easy to overlook the conflicts that took place in East Tennessee, where the battles were often played out in unnamed parlors, backyards and town streets. This aspect of the Civil War in East Tennessee is illustrated in two notable books, *The Bridge Burners* by Cameron Judd and *Mountain Rebels* by Todd Groce.

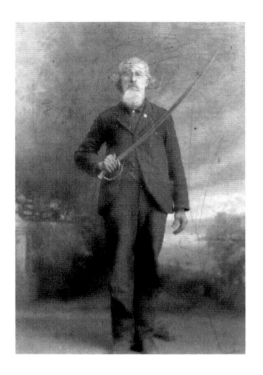

George E. Burger of McMinn County served in the Fourth Tennessee Cavalry (U.S.) during the Civil War, sometimes facing fellow East Tennessee Confederates in battle. East Tennessee was deeply divided in its communities, churches and even families. *Author's collection.*

To the Confederates in East Tennessee, the enemies were not necessarily blue-clad Union troops from some faraway place like Indiana or New York. Here the enemies were neighbors, former friends and many times family members. Almost all of the region's churches split over Union or Confederate support, some not reuniting until years after the war was over, and some still separated to this day.

The strong Union sentiment in East Tennessee caused Confederate authorities to station large numbers of their soldiers here, in an effort to keep East Tennessee under control. This only fueled the fires of the Unionists, which became clear to the Confederates when several East Tennessee bridges were burned in 1861. Suddenly everyone was suspicious, wondering if their neighbor was a Union spy. Meetings were held under cover of darkness, and at times the environment was used to carry out personal vendettas against old enemies. While the Confederates controlled East Tennessee, many Union-supporting families were burned out of their homes, had their livestock taken or lost their property and their businesses, all for the sake of being "Union men," whether they actually were or not. Confederate politicians took

over the offices of local government, and the Unionists had nowhere to turn for help. Many escaped northward into Kentucky, but most remained to wait for a Union victory.

By 1864, much had changed. Gettysburg and Vicksburg had been lost to the Confederate armies the previous year, Grant had broken out of Chattanooga and Burnside had held Knoxville. Now the tables had turned, and the Union supporters in East Tennessee were celebrating the blue Union soldiers occupying East Tennessee as "liberators." And it was time for vengeance.

Suddenly, the Confederates found themselves at the mercy of the people they had abused. Now it was Confederate cattle and horses that were stolen, Confederate homes and farms burned, Confederate businessmen driven out of town. Union men took the political and governmental offices vacated by deposed Confederates, and Union control was established.

But to over-generalize would be in error. Some Confederates, like General Felix Zollicoffer in Knoxville, tolerated Unionist rallies and newspapers with little or no retribution early in the war, and likewise many Union men forgot earlier animosities when they gained control of their communities. And even more often, people changed sides as soon as a new group of soldiers passed through in an effort to appease both sides and to hold onto their livelihoods. Throughout the war, groups of raiders and outliers like the Kirklands and Laneys brought terror to both Union and Confederate alike. The Civil War in East Tennessee is a far more complicated matter than simple battlefields and armies.

East Tennessee has a quality of resiliency that made it possible for old enemies to come together in the years after the war and rebuild local relationships, governments and communities. Although the final effects of the division would last until after World War II, the people of East Tennessee learned to live with their neighbors again and to get beyond political philosophies and divisions.

After a while, we forget old causes and embrace new ones. I share the amusement of bestselling author Sharon McCrumb, who has spoken of young people in East Tennessee who are fond of decorating their

clothing and trucks with "rebel flags," either not knowing or not caring that their ancestors a few generations back were strong Union men who dedicated themselves to overthrowing the very flag their modern-day "rebel" descendants proudly fly.

Somewhere, their Unionist ancestors are rolling over in their graves.

The Confederate General's Emancipation Proposition

He was a dashing Confederate major general, dark haired and an excellent horseman. His name was Patrick Cleburne, a native Irishman who cast his lot with the Confederacy and became one of its most admired military leaders. But what he did on January 2, 1864, seems to go against everything history books tell us about the Civil War, its attitudes and its people. For at a meeting in Dalton, Georgia, Confederate General Patrick Ronayne Cleburne made an ambitious suggestion to his superiors: free the slaves in the Confederacy, recognize their rights and marriages and allow them to fight for their homes against the Union intruders. Cleburne considered slavery "in a military point of view, one of our chief sources of weakness." He believed that such a move would bolster the Confederate ranks, eliminate a vile institution and take away the Union's reason for fighting the war.

Looking back over 140-odd years, we wonder now why General Patrick Cleburne was able to keep his job. A Confederate general openly advocating the abolition of slavery, and the equalization of civil rights? It is even harder to believe when we consider Cleburne's suggestion was much more liberal than Lincoln's Emancipation Proclamation, which actually didn't free any slaves at all. Lincoln only declared the slaves in the Confederacy free, not those in the Union-held areas. Cleburne's actions sound unbelievable, but it is in fact one of those hidden historical truths that few people know about today.

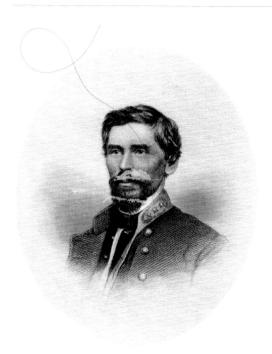

Major General Patrick Cleburne, CSA. What he proposed in 1864 might have won the war for the South and set civil rights ahead more than a century. *Courtesy the Patrick Cleburne Society/Library of Congress.*

To understand Cleburne's idea, we should consider the fact that the year before writing out his proposal he had been stationed in East Tennessee, where the relationships between slaves and their owners were quite unique. For example, the 1860 U.S. Census shows that most of the slave population in East Tennessee was not located on the plantations and farms, but that most slaves were primarily owned by townspeople who were business owners and professionals. These were slaves who lived in the same home, and often worked side by side and ate at the same table with their white owners. Most East Tennesseans did not own slaves, and those who did owned only an average of two to three. The images of *Uncle Tom's Cabin* and *Gone with the Wind* do not accurately reflect the white-black relations in East Tennessee, where it was not uncommon for free blacks to reside and even to own their own businesses.

This was the world that Cleburne was exposed to, a place where racism was certainly present, but not nearly so much as in many other areas of the South. Cleburne surely must have been influenced as he understood that East Tennesseans, both black and white, were exhibiting the signs of something many people hoped for: common

freedom and respect for all men. Cleburne realized the answer to ending the war was to end slavery.

And so General Cleburne issued his proposal to a group of generals meeting in Dalton, Georgia, saying, "We can do this more effectually than the North can now do, for we can give the negro not only his own freedom, but that of his wife and child, and can secure it to him in his old home. To do this, we must immediately make his marriage and parental relations sacred in the eyes of the law and forbid their sale."

Was Cleburne relieved of command at suggesting such a terrible notion? Quite to the contrary: General Joseph Johnson, commander of the Confederate army, was leery of the proposition, but advised it was a governmental matter, not a decision of the military. Generals Bate and Walker supported the idea, and Walker himself sent Cleburne's proposal directly to Jefferson Davis.

Unfortunately, the Confederate government rejected Cleburne's proposal. President Davis did not see the wisdom in Cleburne's proposal, rather believing it to be "injurious," and ordered that it not be released to the public. But in March of the following year, the Confederate Congress offered slaves freedom if they would fight for the South, and some actually did.

By that time, Patrick Cleburne had been killed. Some argue that any hope of promotion was lost due to his opinion to end slavery, resulting in his death while charging the Union lines at Franklin, Tennessee, the following November. But one thing is for sure: a Confederate general would have freed the slaves long before Lincoln's proclamation did, leaving one to ponder what different ending the Civil War might have had if a wise Irish American had gotten his way.

Company Aytch

I found Sam's grave near Columbia, Tennessee, a few years ago. It lies in the center of the Old Zion Cemetery, right off the main path in front of the old church. His headstone is of plain design, listing only his name and that of his wife, along with the years of their births and deaths. I stood there a long time visiting with Sam, a man who died some seventy years before I was born, but in some strange way I feel I know him like an old friend. Every Civil War historian owes Sam a great debt for something he did as an old man, an act so great that his simple headstone fails to recognize it.

Sam Watkins was born in 1839, and was raised in Maury County, Tennessee, and when the Civil War began he enlisted in the First Tennessee Regiment, Company H, with many of his friends from Columbia. Little did Sam and the other men know what was in store for them, for the First Tennessee would be involved in almost every major battle in the west over the next four years.

The First Tennessee missed the first Battle of Manassas by only a few hours, and Sam spoke of how he and his friends felt sure they had missed the only battle of the war, and how he envied the men who were wounded. But then came Shiloh, Perryville, Stones River, Chickamauga, Chattanooga, the Hundred Days Battles in North Georgia, Kennesaw Mountain, Atlanta, the Bloody Battle of Franklin and Nashville. Company H passed through all of these fields of death, and was with General Joseph Johnson when the last Confederate army surrendered at Greensboro, North Carolina, on April 26, 1865. The First Tennessee had enlisted with 3,200 men in 1861. That day in North Carolina, only 165 were left, including Sam.

Sam Watkins was an average soldier, and it is not his military service or for any great acts of courage on the battlefield that he is remembered. Twenty years after the war, as a gift to his grandchildren, he wrote his memoirs. He called the book *Company Aytch*, and it is that record of the common soldier that is treasured by so many Civil War historians today. It saw national attention when much of Sam's writing was used in Ken Burns's *The Civil War* documentary in 1991.

A good portion of Sam's time during the war was spent in East Tennessee, sometimes fighting battles but mostly in mundane camp life. But he relates other personal stories, such as being in Knoxville, proudly walking the street in his ragged uniform, arm in arm with a pretty young girl; at Charleston in Bradley County he enjoyed himself on a short ride with a cavalry unit for a few days; while in Chattanooga he went to witness the hanging of two spies, only to see that they were two young boys, brothers of about fourteen and sixteen years of age. When the younger one cried, his brother kicked him and told him to be a man and "show the Rebels how a Union man dies for his county."

In other places during the war, Sam experienced the loss of a good friend to a tornado, saw men shot for desertion, had many friends killed beside him and played games and engaged in pranks to pass the time in camp. He expressed his fellow soldiers' dislike for generals such as Braxton Bragg, and told of the sorrow the men felt at the deaths of Generals Leonidas Polk in Georgia and Patrick Cleburne at Franklin.

Sam's memoirs are not accounts of troop movements and conclusions drawn upon tactics. He simply told about his day-to-day life in the army, of the death and carnage he saw and what it was like to live through the death, which was sometimes worse than dying itself. When Sam Watkins died in 1901, he had left behind a unique picture of our Civil War and of the common soldier that no historian can do without: "The rains, and sleet, and snow never ceased falling from the winter sky, while the winds pierced the old, gray-back Rebel soldier to his very marrow. The clothing of many

were hanging around them in shreds of rags and tatters, while an old slouch hat covered their frozen ears."

Stories of Stratton Graves

On the modern Cherohala Skyway, as the high mountain road crosses back and forth along the Tennessee–North Carolina state lines, a bridge spans over the old road that once ran across the mountains from Tellico Plains to Robbinsville. The place where the bridge crosses the old road is known as Stratton Gap, and just to the side of the bridge is a headstone that marks a lone grave that only an observant traveler would notice.

The square stone is placed over the remains of A.B. Stratton, whose name was actually Absalom. For many years of driving over the road and hiking in the area, I always assumed that this was the man for whom the gap was named, as well as the nearby Stratton Meadows. But a little research on the grave reveals a much deeper story of the Stratton family.

Stratton Gap was the home of John Stratton, the son of A.B. Stratton. A.B. was born in Wilkes County, North Carolina, in 1772. His son John was born in 1799. Some sources claim that in 1838 John took part in the Cherokee removal. With mountain land open for settlement, John took his wife Alydia up into the wilderness and settled in the gap that bears his name.

John was quite a character, as the stories about him reveal. He lived in the gap for several years, managing cattle left to graze on the high ridges and hunting all manner of wild game. It is said that he killed nineteen mountain lions, or "painters" as they were called, as well as numerous bear and deer. He made enough money from the cattle management and the hides he collected that he was able to eventually purchase a large farm in Monroe County.

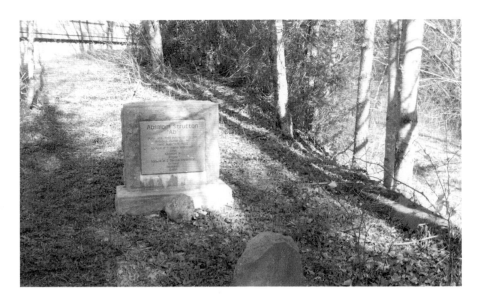

A.B. Stratton died in 1854 while visiting his son John's mountaintop home. Stratton had lived in both Tennessee and North Carolina, and wanted to be buried on the state line between the two with his head in one state and his feet in the other. The lonely grave lies directly beside the Cherohala Skyway at Stratton Gap. *Photo by Stephanie Guy.*

In 1852, Absolom Stratton came up the mountain and paid his son a visit. He stayed at John's house, described as "a big two-story log house about 200 yards inside Tennessee." During his visit, he became seriously ill, so much so that he realized he was going to die. Being so close to the Tennessee–North Carolina line, Bob indicated his affection for both states, and wished to be buried so that his body would be directly on the state line. John and his son Robert cut a large tree and from its wood built the old man a coffin. Respecting A.B.'s wishes, when he passed away his son and grandson buried him with his head in North Carolina and his legs in Tennessee. The grave was marked by a simple stone for many years until the large square rock was placed there.

John Stratton's son Robert was also involved in a bit of history in the area, although the story was much more tragic than that of his father

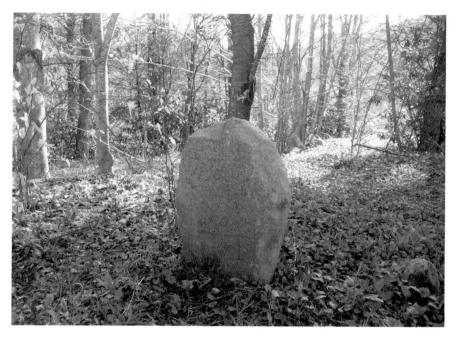

A.B. Stratton's original headstone. Over time, the marker has been chipped away by curious visitors. *Photo by Stephanie Guy.*

John and grandfather A.B. He built his own home near his father, at the top of the mountain known as Stratton Bald. It is related that in September of 1864, with the region deeply divided during the Civil War, Robert went to look for a stray cow accompanied by a friend named Jackson Roberts. Stratton carried a new breech-loading Spencer rifle, perhaps a trophy he had obtained during some prior service in the Confederate army with the Fifty-ninth Infantry Regiment.

As they neared the Ballplay Community of Monroe County, Stratton and Roberts noticed a piece of paper lying in the road. Stratton dismounted his horse and stooped over to pick up the paper when a volley of shots rang out from assassins hidden in ambush on the roadside. Stratton was killed instantly and Roberts was mortally wounded but was able to crawl into a thicket and hide. He said later that he watched as members of the notorious Kirkland bushwhackers emerged from their

ambuscade and took Stratton's rifle from his body. It was a deathbed declaration, as Roberts himself died two days later.

A month passed. On October 3, Robert Stratton's son John, who was only seventeen at the time, was hiding out near the old Tallassee Trail near Rock Creek with a friend named Tom Mashburn. Confederate conscription officers were roaming the area, impressing any able-bodied man into service; the boys were hoping to avoid this fate. A group of bushwhackers, headed by a one-eyed Irishman named Captain Tim Lyons, discovered the boys. The two young men tried to flee, but were shot down and killed. Their bodies were found by some relatives and were wrapped in a sheet and buried in the same grave. Over time, the site was almost forgotten. In 1960, the resting place of the two murdered boys was found, adding yet another page to the sometimes adventurous, sometimes tragic story of the Stratton family and the name they left on the mountains of East Tennessee.

Goldman Bryson: Patriot or Bushwhacker?

Goldman Bryson was forty-six years old when he rode away from Knoxville on October 22, 1863, at the head of a band of Union troops. In his pocket were official orders from General Burnside that read: "Captain Goldman Bryson, First Tennessee National Guard, is hereby ordered to proceed with his command to North Carolina and vicinity, for the purpose of recruiting, and will return here within a fortnight, when he will report in person to these headquarters."

Bryson must have mused over the ambiguous wording of the orders. The term "recruiting" could have many possible implications.

Captain Bryson had been a soldier before, having served during the Cherokee removal in the 1830s, and is believed by some to have also served in the Mexican War. He had grown up in Western North Carolina and was well known there, but by the time of the Civil War

he had established a farm across the mountains in Coker Creek in Monroe County, Tennessee. His motivation to return to service in middle age was shared by many: he was a Union man in deeply divided East Tennessee. For the first two years of the war, Union families had suffered arrests, forced conscription into the Confederate army, confiscation of property, burned homes and barns, physical abuse and even murder as Confederate soldiers and Rebel bushwhackers hunted down anyone who had ever even prayed for the Union. But when Union forces had finally entered East Tennessee in 1863, men like Goldman Bryson found themselves in a position to exact revenge against the Confederates who had previously held sway over the region. Now it was Union bushwhackers riding the back roads.

In August, Bryson had gathered himself a sizeable group of like-minded men, and on horseback they began roaming the area of Monroe County in Tennessee and Graham-Cherokee County in North Carolina, seeking more Union men and punishing any Confederates they came across. "Bryson's Boys," as they were called, were by no means actual soldiers, but were recognized and supported by the Union army. Bryson took full advantage of this fact as he returned to the Tennessee–North Carolina mountains with Burnside's orders that October. He had, within only a few months, established quite a reputation for himself. But to Confederate forces in North Carolina, Bryson's Boys were an obnoxious threat that deserved nothing less than annihilation.

On October 26, Bryson and his force of 120 to 150 men raided Murphy, North Carolina, where they marched through the streets in a show of force and sacked the courthouse. Bryson then traveled back toward Tennessee. But the next morning, his force was surprised at Beaver Dam by Confederates of Thomas's Legion, under command of General John C. Vaughn, also from Monroe County. Thomas's Legion was made up of Cherokee Indians who had embraced the Confederate cause against the Union government that had forced them from their lands thirty years earlier. Bryson's men were routed, with 2 men killed and 17 taken prisoner. The rest, including Bryson, dispersed into the mountains.

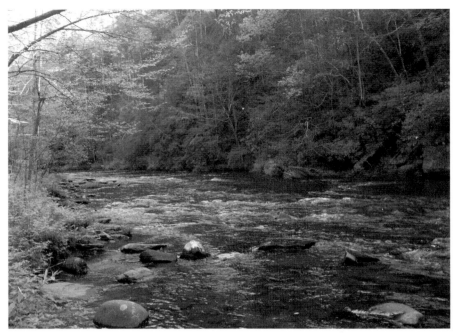

Bryson's captured Union men were executed by Cherokee Confederates on the headwaters of Tellico River near Beaver Dam, close to the North Carolina–Tennessee line. *Author's collection.*

Under their own orders to destroy Bryson's gang, the Confederate force marched the prisoners into the mountains toward Tennessee. Not satisfied that Bryson's Boys were yet eliminated as a threat, the Confederates were determined to see the encounter to its bitter end: near the headwaters of the Tellico River, the seventeen Union men were executed, supposedly under orders from General Vaughn. Then a group of Confederate Cherokees led by Lieutenant Campbell "Camp" Taylor took to Bryson's trail, heading toward Coker Creek, where they knew his home lay.

On October 28, Taylor and his men arrived in Coker Creek. They discovered that Bryson, John Ledford and some other men had camped near a spring across the ridge from the Bryson farm. Taylor and his men surrounded the camp and ordered Bryson to surrender. Bryson, perhaps fearing the Confederates would hang him, refused and turned

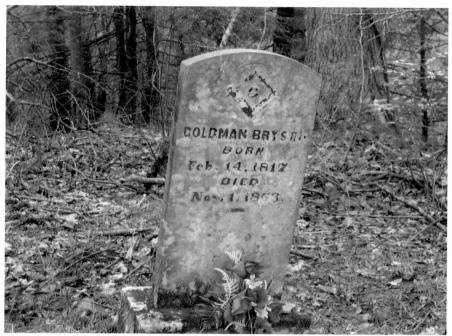

Bryson was buried in a lone grave just across the creek from his home. A marker at the foot of the grave reads, "Killed by Confederate Renegades of Cherokee Descent." The site is now part of the Atlas Davis farm. *Photo by Stephanie Guy.*

to run. Taylor fired, striking Bryson several times and killing him. Taking Ledford as prisoner, the Cherokee Confederates took Bryson's roll papers, stripped the captain of his uniform and the next day returned to Murphy, where they hanged Ledford from a tree near the courthouse. They wore Bryson's bloodied clothing as trophies of war, evidence of their destruction of the Union enemy. Confederate General Braxton Bragg and Carolina Governor Zeb Vance both praised Thomas's Legion for their work in rooting out Bryson's force.

Bryson was buried near his home, and his lone gravestone still stands on the Hubert Davis farm off Smithfield Road in Coker Creek. Bryson's death, however, was not the end of the story. Deep division remained, with the area's neighbors turning against neighbors throughout and even after the war years. A year after Bryson was killed, William Walker, a lieutenant colonel in Thomas's Legion, was

abducted from his very home by vengeful Union men and was never heard from again.

In a strange twist, General Vaughn would be implicated long after the war in a plot to defraud the United States government of thousands of dollars of Union pensions, along with fellow Sweetwater native Thomas Boyd. Not coincidentally, some of the names used in the fraud were those of the seventeen men executed on the Tellico River, names taken directly from the rolls taken from Bryson's body by Camp Taylor.

The Cavalry Girls

Early in the Civil War, with so much Union sentiment located in East Tennessee, Confederate forces flooded the area in order to keep Union sympathies under control, especially after Union spies burned several railroad bridges in 1861. In Rhea County in the summer of 1862, three companies of Confederate cavalry patrolled the deep valley along Walden's Ridge, ranging northeast to southwest. At the time, much of the war was still far away; there had been a battle at Shiloh in West Tennessee and in other places in far-off Virginia. The only enemies these Rhea County Confederates had were their own Unionist neighbors.

Several local young men had volunteered for service as dashing cavalrymen under the commands of Captains W.T. Gass, Bert Leuty and W.T. Darwin. Some of these young men had young wives and sweethearts who grew to miss their men that summer. So a group of about twenty young ladies from Rhea County, between the ages of sixteen and twenty-two, formed themselves into a group. Having access to horses themselves, the girls began to roam up and down the valley armed with food and newly sewn clothing items, which they made presents of when they arrived in the cavalry camps of their husbands

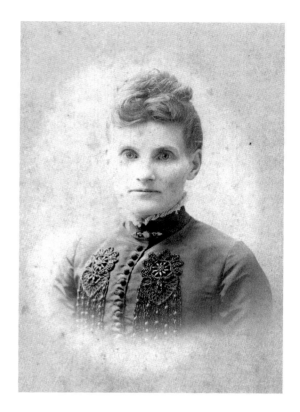

Roda Thomison, second lieutenant of the all-girl Spartans Cavalry in Rhea County during the Civil War. What began as a lark turned into accusations of spying and subterfuge and resulted in the girls' arrest. She is pictured here several years after the war. *Courtesy Pat Guffey.*

and boyfriends. Years later, an article in the April 1911 *Confederate Veteran* recounted the girls' activities and their unintentional "adventure."

That summer, the group of girls organized themselves as a cavalry unit to mimic that of their men, calling themselves the "Spartans." They elected Miss Mary McDonald "captain" and the "lieutenants" were Jeannie Hoyal, Miss O.J. Locke and Miss Roda T. Thomison. The "privates" included Kate Hoyle, Barbara Allen, Jane and Mary Keith, Sarah Mitchell, Caroline McDonald, Jane and Mary Paine, Mary Robertson, Mary Crawford, Anne Myers, Ann McDonald and Martha Early. For several months, the girls enjoyed their carefree rides up and down the valley to visit their men, but as young girls do, in their fun they surely forgot that a war was going on.

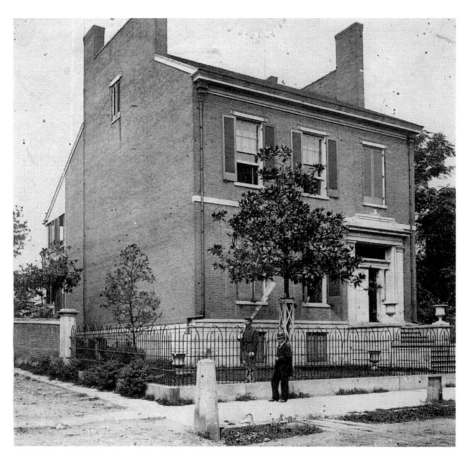

Many of the Rhea County Spartans were known to be from prominent families in the Old Washington community. Captain Walker knew where to find them, and arrested several of the girls there. *Author's collection.*

In 1863, Federal troops had made their way into the valley, driving off the weaker Confederates and allowing the Union element to come out of hiding. One of the Union supporters was a man named John P. Walker, who soon organized a group of "deserters and army stragglers" into a cavalry company and was able to fall under the command of the Fifth Regiment of U.S. Cavalry operating out of Chattanooga. Walker, like other desperadoes of the period, is reported to have turned on his Confederate neighbors, committing routine

robberies and attacks, claiming he would "crush the rebellion" in the valley. He began a campaign that would last two years. Soon, the group of fun-loving girls found that Walker had labeled them as spies and Confederate supporters.

On April 5, 1865, Walker gave out orders for the arrest of all the Rhea County Spartans. The next day, sixteen of the young ladies were rounded up and were marched on foot through the muddy roads to Bell's Landing on the Tennessee River. There, they were put onboard an old boat, called the *Chicken Thief*, normally used to haul hogs, hay and cattle. After being forced to walk ten or twelve miles through the mud, ridiculed by their captors and uncertain of what was awaiting them, the girls were put under guard in a dirty room on the rickety boat.

That night on the river must have been horrifying in the odorous and filthy room, lit only by candlelight, with no privacy and desperate men holding them. Walker was known to be a vengeful man, and he might have taunted the girls with many terrible scenarios that might befall them. They eventually arrived in Chattanooga and were taken to the provost marshal's office, where they were put before S.B. Moe, General Steadman's adjunct. Moe, unsure just what to do, immediately sent for the general.

General Steadman was surely a busy man, and when he viewed the haggard and dirty girls and heard Walker's vile accusations, the general could barely control himself. He openly berated Walker and told Moe to have the girls properly fed and to send them back home. After the meal, the girls were happy at the outcome of their predicament, until they found that they would be forced to travel home again on the foul *Chicken Thief*. While they waited to depart, they were told of General Lee's surrender in Virginia, which saddened several of the girls who had relatives under Lee's command.

General Steadman had ordered Walker to see the girls back home, but to the benefit of the ladies, Walker ignored the order and the girls were on their own. They went up the river again on the *Chicken Thief*, a slower trip this time against the current but at least they were free

of their threatening captors. Eventually, they made it back to their homes and families in Rhea County.

For the rest of their lives, the women could share the stage with many war veterans of their own service, capture and arrest as spies. It all began as innocent fun but became a wartime adventure, as the girls were referred to so many years later as Rhea County's "Cavalry Company of Girls."

The Maple Wood Cane

In a display case in my home is an ancient piece of a maple sapling, about five inches long. A half-inch hole is carved into the end of the small piece of wood, and a few stumps of limbs are still recognizable, the top worn smooth over years of being held in a human hand. It is included in a set of Civil War relics that I use when speaking to school groups, and the piece of maple is one of the items that gets the most questions. When asked, I hand the piece to the students and tell them how maple is a hearty wood when proper care is given to it. The piece of wood is a survivor, and so was its owner.

Andrew Jackson Morgan was twenty-one years old when the Civil War broke out, living near the Monroe–McMinn County lines here in East Tennessee, along the Old Federal Road. For the first year of the war, Andy remained on his family farm, the oldest son to a widowed mother. But two important events changed his life forever in 1862. He married a tall, attractive girl named Jane Maxwell, and along with a group of like-minded young men from McMinn and Monroe Counties, he joined the Confederate army. At the time, a great deal of recruitment was being made in East Tennessee, the largest portion of the state to remain in Confederate hands. East Tennessee men, it was claimed, were to be the best soldiers the war had yet seen.

Andy and the others were enlisted in the Fifty-ninth Tennessee Mounted Infantry. They camped for a while near Morristown, and in the spring were in the area of Niles Ferry near present-day Vonore. Here, Andy was one of the men who swam the river at night, pushing over a raft loaded with gunpowder. With so many Union men in East Tennessee, this was dangerous work that was best done under the cover of darkness.

The Fifty-ninth had been told they would be used to protect the homes and families in East Tennessee, which was a factor in so many having volunteered. But Union General Ulysses Grant was driving south out of Memphis, so in December of 1862 the men of the Fifty-ninth were put on trains and headed south, far from the hills and ridges they knew, to the swampland and heat of Vicksburg, Mississippi.

The promises of glory, of being the protectors of East Tennessee and of the honors of war soon rang hollow for the men of the Fifty-ninth. Heat, fatigue, a lack of supplies and food and broken promises dispersed the naivety of the new recruits. By early May, the men found themselves in battle lines opposing Union forces under Grant. After having been defeated in a skirmish at Port Gibson, the Fifty-ninth under General John C. Vaughn, a fellow Tennessean from Sweetwater, was placed in defensive positions guarding the last railroad that served Vicksburg at the Big Black River Bridge. On May 19, an attack was made by the Union troops directly upon the line where the Fifty-ninth was situated. It was over as soon as it began. The "protectors of East Tennessee" were overrun in one of the worst defeats of the campaign. Over four thousand men were captured, and among them was Andy Morgan. During the following siege of Vicksburg, the prisoners were held in the Union camps, but after the city fell the men were exchanged and headed back to East Tennessee. They were told that they were to be rearmed and sent back into the fighting.

The tales of war often forget the common soldier, but a curious bit of history is recorded about the Fifty-ninth Tennessee. Once back in their home state, men began to disappear from the morning musters. Over time, more and more of the East Tennessee soldiers

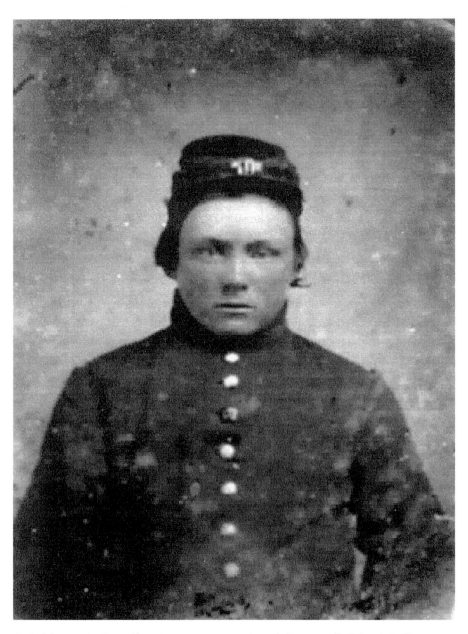

Andy Morgan, in the uniform he wore as a member of Company E, Fifty-ninth Tennessee Mounted Infantry. Like many of the soldiers in the Fifty-ninth, Andy did not return to service after the debacle at the Big Black River Bridge in Mississippi. *Author's collection.*

Pictured is the handle from Andy Morgan's cane. *Photo by Joe Guy.*

were absent without leave. Looking back, it is understandable. These men had seen the horrors of conflict, the true side of the war not told by the fiery speeches of recruiters who spoke of the promises of glory in the newspaper ads. They had seen the mud, the mosquitoes and the exploding cannons that shredded a man. They were independent-minded and shrewd young men who, like maple wood, were accustomed to surviving. With this in mind, it is interesting to consider the fate of Andy Morgan.

In his pension application filed years later, it is recorded that as the troop trains loaded with soldiers of the Fifty-ninth passed north of Calhoun, just inside McMinn County, Andy fell from the top of the train, breaking both collarbones. Being so close to his home, he was released for a spell to recover from his injuries. But when the time came months later for him to return to the war, Andy never went back. What man wouldn't choose a new wife and his farm over the terrors of war? He who is without sin may cast the first stone. Besides, the Union forces were soon in control of East Tennessee. To men like Andy, only a fool would have gone back by then.

As an old man, Andy claimed in his pension that his injuries prevented him from shouldering a musket, that he was essentially disabled. This information should be taken in light of the fact that Andy owned and worked a large farm just inside Monroe County. But due to his injuries, he did in fact walk with a cane for the rest of his

life, a cane that Andy carved for himself. The handle of the cane is all that survives, passed down to his great-great-grandson, made from a five-inch piece of maple wood.

POLITICS, RAILROADS AND MOONSHINE

East Tennessee has dark hollows (properly pronounced "hollers") and clear streams that were well-suited to the making of moonshine; long, deep valleys for the building of railroads; and plenty of stumps for politicians. One does not have to look far to see the connections between the three.

The Whipping Post

Convicted criminals in today's society enjoy quite a comfortable time in jail compared to the sentences meted out in the early 1800s. In most jails in East Tennessee today, a prisoner can look forward to a roomy cell, clean bedding, a county-issued uniform, daily showers, relatively good food, free medical care and cable television. While jail remains the last place in the world anyone would want to be, it is far better than it once was.

In a booklet entitled *Whoooooo Nellie!!! McMinn County Historical Tidbits*, collected by Kenneth Langley, there are several references to crime and punishment in the old days. The *Semi-Weekly Athens Post Century Edition* (1821–1921) relates a vivid description of what is considered to be the

first jail in McMinn County, and no doubt a fair picture of most jails in the region at that time. The building is said to have stood at the corner of present White Street and College Street in Athens, where today one can enjoy the beauty of Knight Park. The "calaboose," as it was called, held those persons who were "hereditarily unclean, personally or otherwise." Built in the early 1820–30s, the building stood on the outskirts of the town, and for good reason. Such places were known for their lack of sanitation and accompanying foul odors.

Another reason the building was placed on the town limits was the fact that it was not only the home of criminals, but also of a smaller and perhaps even more vile offender. The bedding, sometimes consisting of only old blankets and straw, would become infested with "parasites of an extremely objectionable kind." In the summer months, these body lice would have been a terror to any person who was confined to the jail, or even to those deputies who worked there. The punishment inflicted by such vermin would have made even an overnight stay a dreaded affair, and surely was a reason for most people to stay on the right side of the law.

And then there was the whipping post. Although an exact description is not found, one can imagine a large wooden post set into the ground with a metal ring mounted five or six feet high where an unfortunate felon's hands would be bound. Just the image of such a thing gives us cold chills today.

In the June 4, 1832 *Athens Republican*, the following is related: "Ordered by the court that the citizens have liberty to remove the whipping post off the public square and place it on the jail lot." Whether the reason was to remove such severe displays from the town square or to make the post an easier tool to use closer to the jail is not recorded.

Several cases are documented where this type of corporal punishment was used. Old county court records tell of one James Stepp who was sentenced to "be taken to the public whipping post, instantly and there receive on his bare back nine lashes and that he be imprisoned in the common jail of McMinn County for the space of two days and fined five dollars."

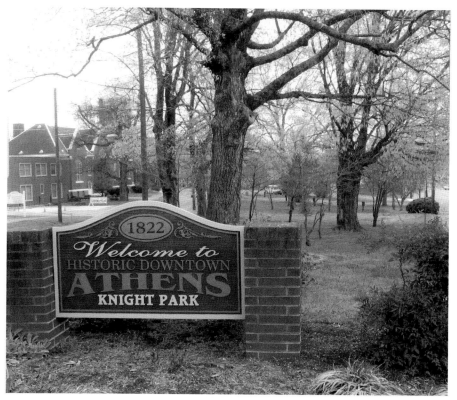

Today's Knight Park in downtown Athens in McMinn County once held the original town jail, whipping post and gallows. Early nineteenth-century Tennessee jails were unsanitary, smelly places that were placed away from the town square. *Photo by Stephanie Guy.*

It appears that the whippings were performed immediately after the court issued its sentence. In the county court of Wednesday, June 8, 1825, Isaac Richards was found guilty of larceny. His sentence was recorded: "That for the offense of the said defendant, he receive five lashes on his bare back, to be inflicted by the sheriff of McMinn County at the public whipping post in the town of Athens at the hour of two o'clock of the present day that he be committed to the jail of McMinn County." One might consider this punishment in light of the court finding the value of the stolen property at $1.50.

As a former deputy sheriff, I often witnessed criminals accepting a sentence of ten days in jail as if it were nothing more than a minor

inconvenience. I can't help but wonder if such a nonchalant attitude would prevail if the whipping post were still around today. And if they had to trade their sheets and cable TV for straw and body lice, would any reasonable person accept their sentence so lightly, or even engage in a crime in the first place? It is certainly debatable, as neither the cruel practice of the whipping post nor long nights spent with a colony of bedbugs served to eradicate crime in the early 1800s. Records indicate that by the time of the Civil War, and perhaps earlier, corporal punishment ceased as a part of the old jail system, and the old whipping post became only a memory.

Ballots, Bullets and Soldier Boys in Benton

The "Battle of Athens" that took place on election day in 1946 recently took center stage in newspapers across the country in remembrance of the sixtieth anniversary of the incident. Several other such confrontations took place in those times of political change in other parts of the South, and like the "Battle of Athens," have been largely placed in the dark closet of historical events that are uncomfortably remembered.

Two years after the "Battle," another election year arrived in 1948. The Athens election day insurrection remained fresh in the minds of many people: political figures still in office, state and local officials, as well as those who saw the efforts of the GI Party and subsequent Good Government League as examples of successful change. In Polk County that year, longtime Sheriff Burch Biggs found his political machine being challenged by the Polk County Good Government League Party. Like in McMinn County two years earlier, a troubling cloud of fierce political campaigning descended on Benton and Ducktown. Polk County was dry tinder waiting for a spark, and few doubted that blood would be shed and lives would be lost if an Athens-style election day shootout were to occur.

August 5 proved those fears to be true. Newspaper accounts from that day reveal that several shootings occurred in Polk County after the polls closed, leaving three men killed and five injured. Almost immediately, Governor Jim McCord, who had been criticized for his lack of action during the Athens incident, activated the local National Guard units. In nearby Etowah, young volunteer guardsmen of Company A were called out of their homes and hangouts; many were not yet twenty years old. They grouped at the old armory before traveling to Athens, where additional men were added, and then to Cleveland, where they were issued rifles and placed on trucks. Their mission: to keep order during the voting counts in Polk County, and to prevent any further violence.

Nearing Benton, the lead truck was stopped by a man on the roadside. The National Guard was not to come into Benton, he said, and he warned of a roadblock ahead. Captain Earl Carmichael told the man in no uncertain terms that indeed they were coming. Carmichael then ordered his men to load their weapons and to arm the .30-caliber machine gun on the front of the truck. He then informed the man that he had ten minutes to clear the roadblock. When the allotted time expired, the guardsmen continued on, unmolested, into Benton.

The guardsmen first took over the Polk County Jail and then marched to the courthouse, where a large crowd had gathered. They dispersed the anxious group, placed guard posts and a machine gun nest around the courthouse and basically established martial law. All roads into Benton were blocked, and all vehicles and persons coming in and out of town were searched. Even a Kyker Funeral Home hearse from Sweetwater was inspected by the wary guardsmen as it passed into town. At least once a car failed to halt at one of the roadblocks until it was fired upon by the soldiers.

Some of the guardsmen were sent to other critical areas, such as Ducktown. There they also established guard posts and slept in a bowling alley. Blood and bullet holes still marked the place where the killings had occurred only days earlier, and the teenage soldiers slept through uncertain nights with their rifles close by.

Ballot boxes were gathered and watched over by the armed guards. When the election was certified, only a select number of men were

allowed into the courthouse, and each man was assigned to a soldier. When the votes were finally counted, the Biggs organization had lost, falling to the same fervor of change that had also defeated Governor McCord and Memphis political magnate E.H. "Boss" Crump.

By August 11, Polk County was secure in the hands of its elected officials. The guard soldiers had completed their mission, and went home with exciting tales of what they had been involved in. Summing up his service record so many years later, Bill Stewart, one of the veterans of Etowah's Company A, said, "I spent my entire military career stateside, but the closest I ever got to actual combat was down the road in Polk County."

The Day Tennessee Dried Up

In the late nineteenth and early twentieth centuries, temperance and prohibition were major American political and social issues, especially in the South. Churches of the region led the fight for Prohibition, and by the late nineteenth century, had begun to actively discipline church members for using alcohol, and sometimes levied actual fines when it was even suspected that a church member had been nipping the bottle. At first the churches in the Appalachian region were fiercely independent, and chose to fight alcohol with no help from the government, which they were suspicious of. But by the late 1800s it was clear that for temperance to be successful it would require the government to pass laws that prohibited the sale and use of alcohol.

In 1877, Tennessee adopted the Four-Mile Law, prohibiting the sale of alcohol within four miles of a church in any rural area. In the summer of 1887, a fight was made to extend the Four-Mile Law to include all rural schools, public and private, chartered and unchartered. This measure would effectively outlaw the sale of any intoxicants in the

majority of rural Tennessee, making Tennessee an almost entirely dry state, at least on paper.

The campaign was an intense one, and emotions ran high on both sides. The "Drys" campaigned on the moral and social ills of alcohol. The "Wets" believed that the legal sale of liquor would encourage business, and campaigned that without the tax revenue, Athens would not be able to build new streets and sidewalks. An industrial boon had hit the South in the 1880s, and the Wets believed to attract new business it was necessary to keep alcohol flowing. The political squabbles were hot, and several men landed in jail due to their stance on the issue. W.F. McCarron, editor of the *Athenian* newspaper, was perhaps the most vocal man in Tennessee in support of Prohibition. He traveled all across the state to speak on behalf of the issue, and is largely credited with the vote's outcome in McMinn and the surrounding counties in the region.

On that summer election day, the Drys hosted a free dinner on the courthouse lawn. Groups of children were marched around the square singing temperance songs. When the day was done, the Drys had won, 242 to 121. Most of East Tennessee voted with McMinn County, although Chattanooga went wet, as did nearly all of the middle and west divisions of the state.

Later, the Drys did away with the incorporation of Athens itself, officially making it a rural area, and thus the Four-Mile Law closed all of the saloons in town, most notably those along the deep ditch that once ran the length of White Street. The Wets countered by voting their own charter for North Athens, and the saloons were reopened there. Historian J.M. Sharp records, "John Gaston built a saloon in North Athens with an open stairway from the street for the man who did not have any respect for himself, and a lot at the rear with a high board fence, and a covered stairway meeting the open stairway upstairs so that new sinners would be screened and take their first lessons in sin." It is clear where Mr. Sharp stood on the issue.

Prohibition would remain a serious issue for almost fifty more years. It would play a large role in the election of Governor Ben Hooper in 1910 and 1912, as the Four-Mile Law was extended to cities as well as rural

areas. But Prohibition would eventually be deemed a failure due to the lack of enforcement, and to an even more apparent lack of compliance on the part of average citizens. Due to its failure, it does not receive much interest or attention. But its effects are still evident even today, as many East Tennessee counties have remained dry all the way into the twenty-first century due to the efforts of Prohibitionists in 1887 and 1912.

Duel on the Kingston Road

Dueling was once a common way for gentlemen to settle differences in the Tennessee hills, as it was over most of the young America in the late eighteenth and early nineteenth centuries. Any insult, or even a perceived slight, could force two men to stand only a few paces apart and shoot at each other. To some it was a ghastly act; to those involved it was frontier conflict resolution.

I've never seen any evidence that the venerable Judge Thomas Nixon Van Dyke of McMinn County was ever involved in such a duel. The practice had been outlawed for some time when Judge Van Dyke came of age. But his father, Dr. Thomas Van Dyke, was very much involved in at least one duel, or at least it was supposed to be a duel, and if it had played out, Tennessee history could have been markedly different.

It was customary in a duel for each combatant to have present with him an assistant, properly called a "second." It was the second's duty to ensure that his man was not ambushed by the other party, that the rules of the duel were agreed upon and followed, that pistols or cutlasses were available and sometimes the second simply stood by and held the horse.

On Saturday, October 1, 1800, Thomas Van Dyke was riding along with a friend of his, a one-time U.S. representative and U.S. senator, a lanky, red-haired man named Andrew Jackson. The two rode in the woods near Kingston, Tennessee, where Van Dyke lived and worked as a

military doctor at Fort Southwest Point. Van Dyke was Jackson's second in a duel that would commence that day, for the fiery lawyer had recently received an insult that had cut so deeply that killing his opponent was the only way to clear his name.

The insult had been directed in a face-to-face confrontation with Jackson's mortal political enemy, the legendary General John Sevier. At one time the two had been friends, but their relationship had been sacrificed on the altar of politics when Jackson had accused Sevier of bribery in a land deal. The dispute became personal, resulting in Sevier bringing up the fact of Jackson's morally questionable marriage to his wife, the former Rachel Donelson Robards. Facing each other on a Knoxville street, Jackson could not and would not forget the insult. He sent Sevier a letter the next day, challenging him to a duel. Jackson was thirty-six, a bit younger than the fifty-eight-year-old Sevier. After much debate, Jackson finally agreed that they should cross to the "nearest Indian boundary line," which was about forty miles west, near Kingston.

Somewhere on the Kingston Road, Jackson and Dr. Van Dyke encountered General Sevier and his son James. The Seviers had brought pistols, but tempers flared and the horses spooked and ran off when Jackson began yelling and swinging his sword around. Without pistols, General Sevier hid behind a tree. James Sevier aimed his pistol at Jackson, which forced Dr. Van Dyke to take aim at James and General Sevier. The horses watched from the distant forest, probably wondering which one of the fools was going to get shot first.

For several minutes, the situation was critical as threats, insults and challenges were hurled across the Kingston Road. Somehow, due to the circumstances, the men finally agreed to part and resume the conflict at another time. But time passed. Their anger and hatred would always remain, but the duel never came about again.

It is interesting to consider "what might have been" out there on the Kingston Road. Had either Van Dyke or Jackson killed the legendary Sevier, the former first governor of Tennessee, renowned Indian fighter and hero of King's Mountain, it is almost assured that Jackson would have been vilified for the deed and thus would have never been able to

seek public office again, and of course very likely would never have been president. The same is true if either of the Seviers had killed Jackson. Dead people simply don't make good presidents.

And of course, had Van Dyke been killed, he would have never fathered one of the more significant characters of the Civil War in McMinn County.

Common Law, Squires and "Shire-Raifes"

Throughout history, government and courts have long been tied together. Ideally, all court systems and government begin with a constitution. Upon settling in the New World, Europeans wrote their own laws, based on the laws from whence they had come. Tennessee's first constitution in 1796 was based largely upon North Carolina's. North Carolina's was based largely upon Virginia's. Virginia's, in turn, drew from the Magna Carta and English Common Law.

English Common Law was a collection of laws brought to England by the Romans, Picks, Saxons, Danes and the Normans. When England was placed under a single ruler, the laws were adopted as "common" to all of its different people and became "common law." Common law was largely oral, because few people could read and write. So once a decision was made, all subsequent decisions followed that ruling, which developed into the custom of legal precedent that we still use today.

In the early days of common law, the king was the "arbiter of justice" and held a court of law. All appeals were made to the king and his court. But some situations arose that laws did not address or had not yet been written for. Sometimes it was a question of fairness rather than law, like property disputes, estates, wills and child custody. Since there was such a dependence on the church at that time, it was assumed that of any institution the church should be able to decide

what was fair. So the king turned the decisions of fairness, or equity, over to the archbishop, also known as the chancellor. This became a court of equity, and became known as chancery court. Chancery court has been in place in Tennessee since 1827.

During the Constitutional Convention of 1835–36, several things changed in the Tennessee courts. For example, divorces had previously been granted only upon petition to the state legislature. It was also at this time that courts were further divided according to the types of cases heard. Cases involving wrongs against the state, in which laws were broken, were heard by the criminal court. Cases involving wrongs done to individuals, called "torts," were heard by civil court. Different books were kept, but often the same magistrates presided over both courts. As court dockets have increased over the years, many cases traditionally heard by civil court are now heard by chancery court.

Tennessee's early court system consisted basically of two parts: the superior court of law and equity and the court of common pleas and quarter sessions, or quarterly court. After the constitutional changes of 1834, the lower courts were presided over by justices of the peace, who were elected by threes from each militia district, and later each civil district. Justices of the peace were an ages-old office based on English Common Law, where trustworthy men in the village or "shire" were appointed to help maintain law and order and act as both judge and chancellor. They were also called "squires." The squires in Tennessee met quarterly over each year, and handled both criminal and civil cases. The squires also made up county court, which oversaw the matters of administration and business of county government. It is easy to see how the close ties of the administrative and judicial branches of local government could encourage corruption, and this was an integral part of political machinery after the Civil War. In 1948, McMinn County, Tennessee, became the first to adopt a county council–county manager form of government. It was challenged in court, but was found to be constitutional in 1949, and since that time it has evolved into the county commission–county mayor form of government used today. The office of justice of the peace was replaced beginning in 1960 by the general sessions judge.

Another judicial office with a bit of history is that of sheriff. The office of sheriff has long been a state constitutional office, and in the early days of McMinn County, Sheriff Spencer Beavers's duties included not only the enforcement of laws, for Beavers was also charged with organizing the county's militia districts, collecting taxes and auctioning property. This less-than-perfect law could make a sheriff quite powerful, and many early Tennessee sheriffs became quite rich from the profits of their offices.

This office of sheriff dates back to medieval times in England, when the rural countryside was divided up into "shires." The king appointed a man to oversee that the king's laws were obeyed by the people living in the shire and that they paid their taxes. This man was known as the "raife." Over time, the title "shire raife" became the "sheriff."

God and the Tennessee Constitution

Jon Meacham is a former *Chattanooga Times* reporter who is now a *Newsweek* managing editor and the author of a new book, *American Gospel: God, the Founding Fathers, and the Making of a Nation.* In this book, Mr. Meacham explores the historical relationship between religion and the founding of America, and how the founding fathers considered themselves servants of "both God and man."

It is interesting that all of the founding fathers were of a general Christian belief system, a system that encourages freedom of choice whether to believe in that system, so long as the person understands the end result of their adherence or rejection according to that system. In the writings of the founding fathers, one theme remains constant: a belief in a God who watched over all people, heard and answered prayers and who would provide either reward or punishment. Meacham debates whether or not the founders meant "God the Father," but it is

certain that most if not all of these men were of the Christian faith, on which they based their philosophy of government.

The importance of religion stands out in the writings of many of these men, as well as in our country's documents. Adherence to a specific religion was not required by law, but neither was it suppressed. The Declaration of Independence speaks of "Nature's God" and the "Creator" who created all men equal and who has endowed mankind with the right to Life, Liberty and the Pursuit Happiness. Governments are instituted by man as a direct result of the endowment of these rights. The God spoken of here is clearly active and interested in the welfare of people, and Jefferson's words show the prevailing respect he had for this God.

The first amendment to the constitution declares that "Congress shall make no law respecting an establishment of religion, or prohibiting the free exercise thereof." Without a doubt, this establishment of religion did not include the naming and recognition of God and Creator in the Declaration of Independence, or in placing "In God We Trust" on our currency.

In the first Tennessee Constitution, written in Knoxville in 1796, the importance of religion was also an issue. In Article IX, a notable disqualification is mentioned regarding holding a seat on the state legislature. Section 1 reads that "ministers of the Gospel are by their profession, dedicated to God and the care of souls, and ought not to be diverted from the great duties of their functions; therefore, no minister of the Gospel, or priest of any denomination whatever, shall be eligible to a seat in either House of the Legislature." The spirit of this section implies that the lawmakers feared not the danger that these ministers would interject religious teachings (note that "Gospel" is capitalized) into lawmaking, but that simply the "great duties" of ministers regarding God and the care of souls vastly outweighed the duties involved with state government. Section 2 of the same article states, "No person who denies the being of God, or a future state of re-wards and punishments, shall hold any office in the civil department of this state." Although ministers were prohibited from holding

legislative office, here is clear evidence of the importance of religion in the lives of lawmakers: a professed belief in God, as well as of the truths of reward and punishment, both as a requirement for holding a state office.

It is an interesting study to consider the importance of religion in the lives and writings of the founders of our nation and state. These men were not perfect; many owned slaves, cheated Indians and were immoral even by today's standards. But their intentions for the role of religion in government were higher than their own human standards, because the standard they drew from was not human at all. Rather, these men looked on a higher power to guide their decisions and to build a country of freedom on Christian principles.

"Better Bring Along a Coffin"

Although it is sometimes depicted as the vocation of lazy hillbillies, moonshining was once a dangerous undertaking in East Tennessee. When liquor laws were passed and law enforcement officers were charged with rooting out illegal whiskey production, moonshiners were forced to turn violent in order to protect their stills. Shine wasn't just a drink of choice; it was also a source of income for poor rural families. There was more money to be made on corn in a bottle than corn in a sack.

But many moonshiners gambled their very lives on their product, and would sometimes give law enforcement information of other operations in order to keep the sheriff away from their own still. This practice of turning on each other proved even more dangerous. One of my great-grandmother's uncles, Dave Rymer, was mistakenly killed in Polk County in the 1930s when an assassin thought Rymer had told authorities where his still was located.

Another such tale of violence involved the Heddon family. Garrett Heddon was a well-known moonshiner in Polk County, and in January of 1908 was in the process of making a "run" of shine along with his son Charles and his nephew John. In a strange twist, Garrett Heddon was wanted for killing his own brother, William, who was John Heddon's father, several years before during an argument.

Polk County Sheriff Burch Biggs had gotten information on the location of the Heddon still on the remote area of Lost Creek, and formed a posse to arrest Heddon and destroy the operation. The posse included Polk County Deputies Joe Williams and Gus Barcley, as well as Monroe County Sheriff Pryor Watson and Deputy Thomas Blair. Heddon, a bold and rugged mountain man, had several times sent a warning to Sheriff Biggs that if he should ever come after him "he'd better bring along a coffin."

Rain was falling that Saturday, allowing the officers to move quietly through the wet leaves on the forest floor and surround the still without alerting the Heddons. A shack stood beside the still, and Garrett Heddon could be seen working outside. At the given signal, Biggs twice ordered Heddon to surrender. Heddon refused and turned to run into the shack, and the officers opened fire. At the same moment, his son and nephew ran outside to see what was happening. Garrett Heddon was killed instantly, and the others were wounded in the crossfire. Charles would survive, but John died soon afterward. Reports would later conflict whether John and Charles were armed. In the shack, the officers found four shotguns and rifles, along with two other men who had been helping in the manufacture. The still was destroyed, and the bodies of the dead and wounded were taken away.

Newspapers gave ample space to the Heddon incident, as Garrett Heddon was a well-known moonshiner in the region and was reputed to be a dead shot. He had been accused of killing several men besides his own brother, and many were fearful of him, including the local sheriffs. But the incident was typical of the conflicts that arose between the independent-minded mountain moonshiner and local law enforcement. In many East Tennessee mountain coves, both moonshine and blood

The dark hollows of the rugged mountainous areas of Monroe and Polk Counties provided moonshiners like Garrett Heddon a place to ply their trade. The mountains became a battleground when armed moonshiners and lawmen met. *Photo by Stephanie Guy.*

ran in those days, and gave rise to many characters and legends, some moonshiners, some sheriffs and some both.

War of the Roses at White Cliff

The first Taylor brother came to Athens in 1876, a slim, dark-haired, mustached young man named Robert, although his friends called him Bob. He attended college at East Tennessee Wesleyan while his father, Nathaniel Greene Taylor, preached at the Methodist church. The elder Taylor was a graduate of Princeton and was a former state representative

from Carter County, and was a U.S. representative upon Tennessee's return to the Union in 1866.

Bob returned to Jonesboro after college, where he farmed and practiced law. He became interested in politics along with his brother, Alf. In 1878, when Alf lost a nomination to a Republican congressional seat, Robert was encouraged to put his name on the ballot as a Democrat, and was promptly elected. The political rivalry between the two brothers would continue, and when Alf ran as a Republican for governor in 1886, Robert came out against him as the Democrat candidate.

The rivalry offered a unique opportunity for both men, who cherished their brotherhood far above politics. Alf's supporters wore red roses and Bob's wore white. The governor's race became known as the War of the Roses. The brothers traveled together, ate together, slept together and debated each other all over the state.

In August of 1886, the War of the Roses came to Athens. In J.M. Sharp's memoirs, he recalls that the Taylor brothers spoke to a large crowd from a platform built at the old high school, near the old Blizzard residence on White Street. Bob spoke of his brother and their different political philosophies: "My brother is a red rose. I am the white rose. Very early in life when I was a tender bud, I was transplanted from the Republican flower garden to the garden of Democracy, while my brother languishes in the old garden. Full many a rose is born to blush unseen and waste its fragrance on the desert air...Alf has one consolation: he will be brother to the governor." Alf replied that he was "going over to the Democrat garden and pluck the flowers of a wilted white rose." During Alf's speech, some Democrats heckled him, which caused Bob to stand up and declare, "This is a war of ideas; it is not a war of brothers, and any man who insults the Republican candidate insults the Democratic candidate."

Later that same visit, the Taylors rode up to the White Cliff Hotel on Starr Mountain, where another debate was held, followed by a fiddling contest between the two brothers. Newspapers from Nashville, Knoxville and Chattanooga, as well as those from Athens, had correspondents present and carried stories of the event. The speeches that hot summer

day were often laced with humor, as is recorded by R. Frank McKinney in *Torment in the Knobs*. Bob told of their carriage ride to the mountain from Happy Top (now Englewood):

> *I was traveling along with Alf in our rig when I spotted a young boy sitting on a split rail fence, clad in only his pants. We stopped the rig and I said to the boy, "Where's your shirt?"*
>
> *"Maw's a-washing it," he replied.*
>
> *"Don't you have another shirt?"*
>
> *The boy swore and answered, "How many shirts do you think I ought to have—a thousand?"*

Bob would defeat Alf that year, and would enjoy three terms as governor, then would become a U.S. senator, dying in office in 1912. He was buried in Knoxville. But Alf would continue to pursue the governor's seat, and would finally be elected in 1920. He retired to his home in Johnson City, where he died in 1931.

But the brothers who had campaigned so hard against each other would not rest long in graves so far apart. In 1938, Bob's remains were moved to a grave beside Alf's in Monte Vista Cemetery, allowing the two brothers to sleep their last sleep as they had done so many times in life: side by side.

Tennessee's First Railroad

The 1830s were a period of tremendous change in Tennessee. Still living at that time were people who had experienced the French and Indian War, the Revolutionary War, Tennessee's transition from a territory to statehood and the War of 1912. But by the 1830s, Tennesseans were looking toward the future, and to many that future would arrive by rail.

Railroads were cutting-edge technology in those days. Imagine living in a time when all personal travel and shipping of goods were done either by wagons or with the flow of the rivers. Many small settlements were limited in their growth if they were too far from a river port or did not have adequate roads, and so the prospect of a machine that ran on rails that were connected to other towns and could be built over almost any terrain was revolutionary, although expensive. The only question was what part of the state would be able to secure funding to organize such a thing.

Newspapers began to editorialize their readers in support for railroad development, which caught the attention of men of means who realized what money could be made in such a venture. In November of 1835, the support culminated in Nashville when a bill was introduced that included a general system of improvements in the state. Along with this bill was a letter from General Edmund Pendleton Gaines. Gaines stated that the area around Athens in McMinn County would be well suited for a railroad extending to Georgia, where it could connect with the Atlantic and Mississippi Railroad at the Coosa River.

On February 19, 1836, the Hiwassee Railroad Company was incorporated by an act of the general assembly. Many influential men bought stock in the company, including T.N. Van Dyke and newspaper mogul Sam Ivins. The railroad was to build a line from Knoxville to a point on the Georgia line.

Work on the Hiwassee Railroad began in late 1837, and although another railroad had obtained an earlier charter, the Hiwassee was the first in which actual construction was done. The main office was located on Jackson Street in Athens, in a brick building that still stands today, constructed by slave labor under the direction of Samuel Cleage. Behind the building was the residence of the railroad's director. The early rails were wooden, with a strip of metal on top. Engines were wood fueled, and the primitive coaches were open aired. The trains made frequent stops so passengers could gather wood so their trip could continue. Work continued over the next seven years with about sixty-five miles of grading completed, a few miles fewer of track laid and at least one bridge being

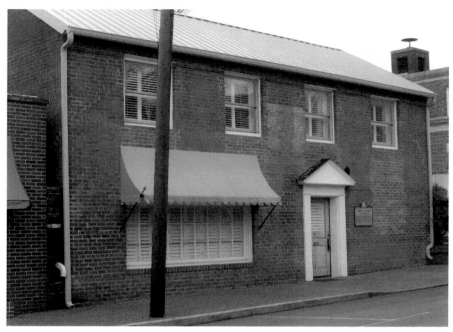

This structure was built by Samuel Cleage around 1835 to house the offices of the Hiwassee Railroad. Construction on the Hiwassee appears to have predated any other rail line in the state, but the line eventually went bankrupt with only sixty miles complete. It later became part of the East Tennessee and Georgia Railroad in 1847. The building remains in downtown Athens in McMinn County. *Photo by Stephanie Guy.*

built over the Hiwassee at Calhoun. But due to financial difficulties, the company went into bankruptcy in 1842.

For ten years the line lay quiet, but the forces to obtain a railroad for the area continued to go forward. In 1848, the East Tennessee and Georgia Railroad was chartered, and took in the former Hiwassee Railroad. Work commenced almost immediately and the line crept south toward Dalton and north to reach Mouse Creek (Niota) in 1852, through Sweetwater, crossed the Tennessee River at Loudoun and by 1855 trains had reached Knoxville. The Mouse Creek/Niota Depot, built in 1854, remains the oldest standing depot in the state. The East Tennessee and Georgia was later taken in by the present Southern Railway System.

Today it is interesting to consider that Athens had a rail line under construction long before either Knoxville or Chattanooga, and although Chattanooga later became known as a railroad city, Athens had trains running ten years before Chattanooga.

People often wonder, upon a close inspection of a modern map, why today's Southern Rail line curves in a "dog leg" out of the Sweetwater valley, runs through Athens and then curves back to resume its straight path northward and southward. The reason is because the first construction was done in Athens, on the first railroad in Tennessee.

The Oldest Depot in Tennessee

Old buildings are monuments to the past, providing a tangible piece of history that people today can see, touch and experience. As time passes, fewer and fewer such structures remain due to demolition, wear and modern development. It is even more rare when a significant historic structure is being utilized today for a useful purpose.

Most sources agree that the old railroad depot in Niota, Tennessee, is the oldest standing depot in the state. Built in 1854 and opened the following year, the town was then called Mouse Creek, and the depot stood beside what was then known as the East Tennessee and Georgia Railroad. At the time, railroads were cutting-edge technology, drastically improving travel, shipping of goods and speed of communications through the U.S. Postal Service. The same year the depot was finished, the first train to ever reach Knoxville completed its journey, no doubt passing by the Mouse Creek Depot on its journey.

The depot would have been a center point of the community, a place where people would gather in expectation of an approaching

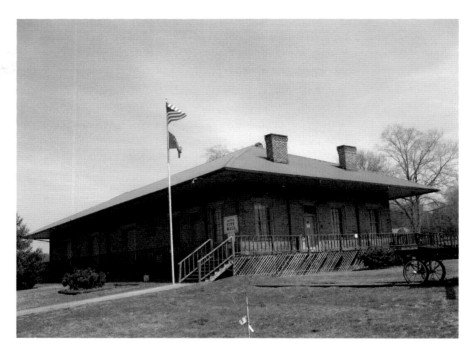

Built in 1854, the Niota (formerly Mouse Creek) Depot in McMinn County is the oldest standing railroad depot in the state. *Photo by Stephanie Guy.*

train with its coal-burned smoke rising in the distance and the steam whistle announcing its arrival. It was a place to see if any new person stepping off the train might bear news from another distant place, or become a new family looking to set down roots somewhere in the valley. Baggage men would load and unload bags and boxes onto the freight platform as the conductor and engineer checked over the coal levels and steam valves in preparation of moving along on the next portion of their trip. Clerks inside the depot sold tickets and answered questions as they filed papers on travelers and shipped merchandise. The conductor would confirm his watch with that of the stationmaster, check for any telegraphed orders related to trains ahead of and behind him and at the designated time would direct the engineer to blow the whistle for the "All Aboard." Soon, the

Inside the Niota Depot. This is one of the "portholes" believed to have been made for soldiers to monitor approaching trains during the Civil War. *Photo by Joe Guy.*

engine slugged away from the platform, laden with its passengers and freight, down the track to its next stop.

With the Civil War came a new use for the railroad: moving military troops, supplies and equipment to and from battlefields and camps. It was the first time in world history such a thing had been done, and the Mouse Creek Depot was part of this. With so much division in McMinn County and East Tennessee, the railroad depot was again a hot point of activity. Spies closely monitored the rail lines to measure troops going and coming, and often plotted to destroy bridges to bring the trains to a halt. At different times, depending upon whether it was Union or Confederate forces that occupied Mouse Creek, the brick depot made for a formidable fortress for wary soldiers. At some point, it is believed that sections of bricks were removed from the walls to form gun ports, which today are still visible on the interior.

As the war ended and the prosperous times came in the late 1800s, the depot again became a hub of commercial activity for shipping and travel. Today, its interior walls show the "graffiti" of its clerks

and customers who wrote their names on the walls and doors, some even including dates. In 1897, Mouse Creek changed its name to Niota in order to solve the confusion over mail being delivered in error to Mossy Creek in Jefferson County. The depot remained in use by Southern Railway until 1972, and with the building slowly decaying, the Town of Niota was able to obtain it from the railroad in recent years. The building has since become useful to the community again as Niota City Hall and government offices, as well as providing an ample and quaint location for weddings and other events in the old baggage area.

The Niota Depot is the last of its kind, surviving years upon years to the present, a piece of McMinn County and Tennessee history that still can be seen and experienced, as it is still telling stories and making memories for the people of Niota.

The Poll Tax: When Voting Wasn't Free

In the English language, spoken for more than three centuries, the word "poll" was a reference to "head." In the government systems of those days, when taxes were levied against individuals, a "head" or "poll" tax was assigned to adult males. This tax was paid throughout adulthood, and was relieved once the man grew old, which was considered to be fifty years old at the time. In fact, any tax on an individual not levied for property, services or goods was considered to be a poll tax.

In early America, these types of taxes were brought over as a means to help bring in funds for government. In Tennessee, all free males between the ages of twenty-one and fifty were required to pay the tax, even free black males. It was during this time that the notion of a free man's right to vote was honored, and so both free whites and blacks paid a poll tax and could vote in elections in Tennessee until

the state constitution was changed in 1835, when only free whites could vote. Slaves could not vote, but the slave owner paid a poll tax for each male slave owned. Paying such a tax and being able to vote were considered to be tied directly to one another, especially since early voting consisted of headcounts. Thus, the term "going to the polls" meant going to vote.

As taxation of free adult males and the right to vote became interrelated, the use of a poll tax became a political tool. Requiring every free male to pay the poll tax limited the ability to vote to only those men who could afford to pay, and to those who were white. If a person was black, Indian, a woman or simply too poor to pay the tax, then he or she could not vote.

This directly impacted control of elections, and allowed for a great deal of fraud and abuse. Many times, even though a person had paid his poll tax, his name would mysteriously disappear from the list, especially if his political views did not support those who were in power and controlled the poll lists. On the other hand, receipts for paid poll taxes were easily obtained, sometimes hundreds at a time, and were passed out to people to use to vote, so long as they promised to vote for the person who had bought all the receipts.

After the Civil War, the fifteenth amendment guaranteed the right to vote to all males, regardless of race. But the poll tax was still in place, and was used in many places to control the black vote. Again, a person could be too poor to pay the tax, or his name was lost from the list and so on. Some states provided a "grandfather" clause in the poll tax law that allowed any adult male whose father or grandfather had voted in a specific year prior to the abolition of slavery to be able to vote without paying the tax. This, of course, would apply only to whites. Thus, only blacks and Native Americans were required to pay to vote. In 1920, women were given the right to vote, as well as pay their poll tax.

It would not be until 1964, with the ratification of the twenty-fourth amendment, that poll taxes were outlawed entirely. At the ceremony formalizing this amendment, President Lyndon Johnson noted, "There can be no one too poor to vote." *Harper v. Board of Education* in 1966

extended this concept to rule that poll taxes in state elections violated the Equal Protection Clause of the fourteenth amendment. Mississippi was the last state to strike down its poll tax on April 8, 1966.

Over thirty years later, it is difficult to imagine that any person would be required to pay a fee in order to vote. But for almost all of our national and state history, this was true. The freedom to vote is something available to all citizens, and is a freedom that we should enjoy and exercise, considering in our not-too-distant past this right was easily taken away or manipulated. We should not easily forget that only a few decades ago, voting was not a right, since people actually had to pay to vote.

THE CHEROKEE

Wherever one travels in East Tennessee today, the shadows and footprints of the Cherokee remain. They left us with place names, stream names, trails now followed by highways and roads and every now and then they are honored by a high school mascot. But the great truths they left behind are still present in their legends, their stories, their struggles and their history.

Dusk falls at the Chota Memorial, along the banks of the Little Tennessee River/Tellico Lake in Monroe County. The memorial stands over the location of the Cherokee Council House. *Photo by Stephanie Guy.*

Cornstalk's Indian Confederacy

There were at least twelve of them, all men of renown in their own nations, their bodies decorated in tattoos, their clothing a mix of colorful modern cloth adorned with beads and silver trinkets. Most had long hair, also adorned with silver baubles and feathers of wild turkey, eagle or hawk. For seventy days they had ridden southward in a great arc, stopping at different villages to meet with the people, smoke their pipes and tell them of a prophecy that was already being fulfilled.

They were all chiefs of different Indian nations who had once looked upon each other as enemies. But they had been brought together by the man who now led them, a Shawnee known as Cornstalk. When they arrived in the Cherokee towns in the summer of 1776, they bore a dire message. While the British were busy fighting a war with their American children, whites were pouring into the Indian lands to the north looking for free land, ignoring the boundaries set by the English king.

More and more, the Indians had been pushed back. Perhaps the Shawnee had suffered the worst, as they were a wandering people with no true home. As the whites pushed into the rich lands along the Ohio River, which the Shawnee called the Splay-la-with-eepi, Cornstalk's people found themselves constantly harassed by white land grabbers and hunters. All his life Cornstalk had seen this coming, while the Indian tribes often ignored the threat while fighting among themselves. Cornstalk realized that there was only one way to stop the whites, and that was for all Indians to forget their differences and unite as one force against the white aggressors. If they did not, they would all be destroyed.

This was the message he delivered to the Cherokee gathered in their townhouse at Chota that summer night. One of the men with him was a Mohawk who presented the Cherokee with a war belt and gave them a strong admonition: "What is now the case of my people may be the case of any nation another day...My people have sent me to secure the friendship of all nations of Indians...the red men must forget their quarrels among themselves and turn their eyes and thoughts one way."

The talks went on for some time. Many of the famous Cherokee were there: Dragging Canoe and John Watts of the Chickamaugas, Nancy Ward, the aged Attakullakulla and Oconostota, perhaps the greatest war chief the Cherokee would ever know. From their seats of honor, Attakullakulla and Oconostota listened in silence as Cornstalk finally rose to speak.

In a few years, the Shawnee, from being a great nation, has been reduced to a handful...now have hardly enough ground to stand on. The lands where the Shawnee have but lately hunted are now covered with forts and armed men. When a fort appears, you can depend on it, there will soon be towns and settlements of white men. It is better to die like warriors than to diminish away in inches. The cause of the red men is just, and I hope the Great Spirit who governs everything will favor us.

What Cornstalk was proposing had never before been done. Could the nations forget their differences and unite as one force? After more ambitious words, Cornstalk produced an impressive war belt. It was made of purple glass beads and was nine feet long and six inches wide. Over it he poured red vermillion, signifying blood and war. Standing in the center of the room, he held it out to the assembled Cherokee. Anyone who came out to touch the belt would signify his support to Cornstalk's plan.

The five hundred people in the council house stirred for a moment, and then young Cherokee warriors began pushing their way toward the Shawnee chief. Each touched the belt, publicly showing the intents of his heart. Dragging Canoe, already known for his stance against the whites, was one of the Cherokee leaders who also took hold of the symbol of war.

But the old warriors kept their seats, including Attakullakulla and Oconostota. Both had been warriors in their younger days, but perhaps they realized the futility of Cornstalk's proposal. Both had seen the great ships of the British and Americans, bristling with cannons. Both had seen the great armies with a seemingly endless supply of guns. Perhaps,

The Chota Memorial near Vonore in Monroe County marks the location of the historic capital of the Overhill Cherokee Towns. Here, in 1776, Shawnee Chief Cornstalk visited in an attempt to rally the Cherokee to unite with his proposed Indian Confederacy to fight against the white colonists. His impassioned pleas were not heeded by the Cherokee, and the defeat of all the Eastern tribes was complete within sixty years. *Photo by Stephanie Guy.*

as Cornstalk and his delegation departed, they thought that they would remain safe in their Overmountain towns, and Cornstalk's warning would not come true.

Despite his efforts, Cornstalk's Indian confederacy would soon fail and he would be dead. And within the year, the Cherokee towns along the Little Tennessee River would be visited by an American army. It would not be the last. Within two generations, the last of the Cherokee would be sent west along the Trail of Tears. Whites would possess the very land the Chota council house stood upon, proving the words of Cornstalk and his Mohawk allies.

Lost Tribe of the Hiwassee

In the spring of 1714, Eleazer Wiggan sat around a council fire in the Cherokee town of Tanasi, near what is now Vonore, Tennessee. Wiggan was a British trader who lived among the Cherokee. He was called "Old Rabbit" by the Indians, as he was short, shrewd and sneaky in his dealings. In the council house at Tanasi with several of the Cherokee leaders, he listened closely for an opportunity to turn the Cherokees' attention to a matter that would have a great affect on his trading business.

Wiggan had been a trader for several years, hauling his wares of guns, powder, lead ball, flints, copper kettles, trade silver, hatchets, shirts and blankets from distant Charles Town in the colony of South Carolina. Passing over the mountains, he sold his trade goods from a shack he'd built in Tanasi. He did a productive business with the Cherokee, but he knew he could do better.

About thirty miles south of the Cherokee towns, another Indian tribe lived along what was once called the Ayuwasi River, now the Hiwassee. These were the Yuchi Indians, who called themselves the "Tsoyaha yuchi," meaning "children of the sun from far away." The Yuchi were also called the "round town people," as they often lived in villages that were encircled by protective palisades of sharpened poles. They were a warlike people who lived side by side on often uneasy terms with their Cherokee neighbors. Wiggan also traded with the Yuchi, but he didn't seem to do as well with them. Simply put, the Yuchi insisted on paying less in deer hides than the Cherokee did, so as far as he was concerned, the Yuchi were not good customers. And so Wiggan had come up with a plan to rid himself of the Yuchi, and he would use the Cherokee to accomplish this.

As the council continued, one of the chiefs, whom Old Rabbit had already been plying, brought up his growing disgust with their Yuchi neighbors. They were bothersome, he accused, and untrustworthy. Others began to speak of rumors they had heard: that the Yuchi had been courting the favors of the Cherokees' mortal enemies, the Spanish. These, of course, were lies that Old Rabbit himself had spread, and Wiggan smiled wryly as he saw his plan unfolding perfectly.

"I wonder," said Wiggan, "why the Cherokee, who are so strong and mighty, would tolerate the perfidy of the Yuchi? If the Cherokee chose to do so, the Yuchi could be wiped away, and their towns would become the property of the Cherokee, making the Cherokee even stronger."

The Indians listened intently to Old Rabbit. Some of the older leaders disagreed with such action against the weaker tribe, but many of the younger chiefs, led by the warriors called Caesar and the Flint, were already inflamed at Wiggan's rumor-spreading, and soon were clamoring for an attack on the Yuchi. Days later, the war party headed south.

The main Yuchi village was located on the Ayuwassee River at Tsistowee, or as the whites called it, Chestuee, at the mouth of the creek of the same name, not far below the mouth of the Ocoee. With Wiggan and fellow trader Alexander Long supplying the guns, the heavily armed Cherokee stormed the town's walls in a surprise attack. The surviving old Yuchi men, women and children gathered in the communal house and committed mass suicide rather than be taken captive. A woman and a couple of children survived and were taken as slaves back to South Carolina, where they told their story to officials. Other battles were fought farther west at Yuchi Old Fields in present Meigs County. Officials with the board of trade in Charles Town were not happy when they learned of Wiggan's exploits. Long and Wiggan both were arrested for promoting their particular interests, were tried and convicted of inciting Indian war and were stripped of their trading licenses.

Wiggan would later return to trading, and would be an influential translator during a later Cherokee visit to King George in 1730, along with a young Cherokee warrior called "White Owl," later known as Attakullakulla.

As for the Yuchi, the remainders of the tribe drifted south to become part of the Creek nation, while a few remained and were eventually accepted into the Cherokee. But due to the plot of a greedy trader, the Yuchi disappeared from Southeast Tennessee forever. Now only a small community and boat dock in Meigs County retain

the "Euchee" name. But this tribe did leave Tennessee with one important legacy. The Yuchi referred to the confluence of the French Broad and Holston Rivers in their language as Tana-tsee-dgee, which translates roughly to "where the waters meet" and literally means "brother waters place." The name of the Cherokee town of Tanasi was derivative of Tana-tsee, and this name was later corrupted to the name of the region, and later the state, of Tennessee.

Nickajack: Last Battle for the Cherokee

Driving over Interstate 24 west of Chattanooga, thousands of vehicles pass over the modern bridge over Nickajack Lake every day. Beneath the bridge, the waters of the lake shimmer with fishing and pleasure boats floating over the scenic TVA reservoir. To the north is the community of Haletown and the Highway 41 Bridge; to the south the lake lies like a silver quilt over the valley behind Nickajack Dam, two miles in the distance.

But beneath the gray lake waters that lie below the roaring interstate, underneath the surface where the boaters and fishermen play, lies some hidden history. Just downriver of the interstate bridge was once the Cherokee town of Running Water, and a little farther down the valley was the town of Nickajack. It was in these valley towns that the last stronghold of the Cherokee Nation fell, opening the way for the settlement of Tennessee.

In 1776, this section of the Tennessee River valley was a no-man's land. The only roads in or out were the secret paths of the Cherokee who sometimes came to camp and hunt here. Certainly, there was the river, always restless in the confines of such a narrow valley. Only a few miles upstream, it passed through what was called "the narrows," where two natural obstacles—the boiling pot and the suck—made any river

View of Nickajack Lake. In the distance is the location of the Chickamauga Cherokee town of Nickajack that lay on the bank of the Tennessee River. Its destruction in 1794 effectively ended the Chickamauga threat to the Western frontier settlements. *Photo by Stephanie Guy.*

passage difficult or even impossible. When Fort Loudoun fell in 1760, the French governor in New Orleans sent a boat of French soldiers and traders to occupy the fallen British fort. The boat made it all the way up the Mississippi and then the Tennessee until it foundered at the suck. Had it made it to present-day Monroe County, Tennessee history might have been very different.

The natural obstacles of the river and the steep valley are what attracted a disgruntled group of Cherokee who became known as the Chickamaugas, led by their portly war chief Dragging Canoe, to establish new towns here in 1781. They first had built towns near present-day Chattanooga, but in 1776 they moved farther downstream into the natural "citadel," a river valley surrounded by high mountain ridges. From here, Dragging Canoe and his Chickamauga Cherokee controlled the river, attacking any boats of settlers that might drift down toward new

lands in Middle Tennessee. It was also a safe haven for Dragging Canoe to operate out of, leading raids all over East and Middle Tennessee on white settlements and forts. Other renegade Creek and Chickasaw, along with expatriated English and French outlaws, joined him, and for a time it became the most dangerous section of the river to pass. Many flatboats and canoes were overtaken in this valley, and many nameless settlers were lost to the fury of the Chickamauga.

Their reputation grew, and this had a direct affect on hindering the settlement of lower East and Middle Tennessee. Few settlers would venture into the lands that Dragging Canoe claimed. American soldiers made some attacks, but none seemed to penetrate the deep valley where the towns of Running Water and Nickajack lay. Only the Cherokee knew the paths through the surrounding mountains.

But in 1792, two important events occurred: Dragging Canoe died at Running Water and a young man named Joseph Brown arrived in the Cumberland settlements around present-day Nashville. Brown told stories of his life as a child—how in 1788 his family's flatboat had been overtaken by the Chickamauga at Running Water Town and how his father and brothers had been killed. He and his sisters had been spared and were adopted into the tribe, and there he had lived for a few years before being exchanged. He shared with the Cumberland residents his knowledge of the Chickamauga towns, especially the hidden paths. James Robertson, leader of the Cumberland settlements and "father of Tennessee," realized the usefulness of Joseph Brown's knowledge, and quickly formed a plan to attack the Chickamauga and destroy their hidden valley towns once and for all.

Acting as a guide, Brown led a force of 550 men under the command of James Ore southeast along present-day Highway 41, where half of the men crossed the river in the area of South Pittsburg. Brown took them through the secret mountains passes, and on September 13, 1794, they completely surprised the Chickamauga. After an all-day fight, Nickajack and Running Water were burned to the ground, and numerous Cherokee warriors were killed.

With the last of the hidden towns in ashes, the Chickamauga joined with the towns on the Little Tennessee to sign a firm peace

treaty with the Americans at Tellico Blockhouse near present-day Vonore. The nation began to adopt the white practices of farming and weaving, effectively ending the Cherokee war machine. With the Chickamauga removed, the river flowed freely, opening the way for the eventual settlement of the Southeast. And so ended the story of the fabled Cherokee warriors and their valley citadel, now hidden somewhere beneath the dark waters of Nickajack Lake.

The Legend of Madoc

In the year 1170, a ship named the *Gwenan Gorn* left the coast of Wales. It was commanded by a Welsh prince, Madoc ap-Owain Gwynedd, and held a group of fellow Welsh adventurers. Madoc was the last of the seventeen sons of King Owain Gwynedd, and after the death of his father Wales erupted in war between Madoc's brothers. Having no desire to fight with his family, Madoc decided to travel to a distant land, far to the west over the ocean, a place it is believed he had visited before. The following year, it was recorded in Welsh history that Madoc's ship had "ventured far out over the Western ocean never to return," and so it was assumed that Madoc and his friends had been lost at sea. Yet a legend remained that Madoc had not perished, but had found a distant land after all.

Three hundred years later, Christopher Columbus was a swashbuckling mercenary sailor known as a corsair. He had heard about Madoc in his travels between Iceland and Portugal, and Columbus was intrigued by the legend. This information was part of the reason Columbus petitioned Queen Isabella to fund the historic voyage on which he "discovered" America. Columbus, on his second voyage, saw old wrecked ships of European design in the area of the West Indies, and wrote on his map that "these are Welsh waters."

Then there is Quetzalcoatl, an Aztec Indian god who was depicted as a white man with a yellow beard. When Hernando Cortes invaded present-day Mexico in 1520, he learned of the "white god" legend and that Quetzalcoatl had visited the Aztecs many years before and had promised one day to return. Cortez pretended to be the fabled Quetzalcoatl, and thereby overthrew the Aztec Indians. There are those today who connect Quetzalcoatl with Madoc.

In 1810, former Tennessee Governor John Sevier recorded a conversation he had many years earlier with the famed Cherokee Chief Oconostota. While conducting a military operation against the Cherokee in 1782, Sevier saw several strange-looking stone fortresses in the area of present-day Chattanooga. He inquired of Oconostota of their origin, to which Oconostota replied, "It is handed down by the forefathers that the works had been made by the white people who had formerly occupied the country now called Carolina [Tennessee]." When Sevier asked who the white people were, the chief answered that "he heard his father and grandfather say that they were a people called Welsh, and they had crossed the great waters and landed first at the mouth of the Alabama River near Mobile and had been driven up the heads of the waters until they arrived at Hiwassee River."

In 1854, Benjamin Bowen recorded the tale of an Indian who spoke of ancient white people who once lived on Conasauga Creek. Even today, stone fortifications remain at places such as Old Stone Fort in Manchester, Tennessee, Desoto Falls on Lookout Mountain and Fort Mountain in Chatsworth, Georgia. Archaeologists and historians remain puzzled as to who actually built these sites.

Other stories remain of early hunters with light skin and blue eyes encountering Indians in the Appalachian region. In many Indian cultures there are stories of whites who had come to them long ago, long before the Spanish. Some Indian language supports this theory: "wolf" in Cherokee is "waya," and in Welsh it is "wayman." Shawnee words such as glass, father, old, water and dance match the Welsh words almost exactly. Ancient Roman coins have been found in Mobile Bay, Louisville, Kentucky, and as far west as Missouri.

In this view, the top of the ancient one-thousand-year-old earthwork known as the Old Stone Fort in Manchester, Tennessee, is visible. The wall encloses a fifty-acre field to the right, and borders the Bark Camp Fork of the Duck River to the left. *Photo by Stephanie Guy.*

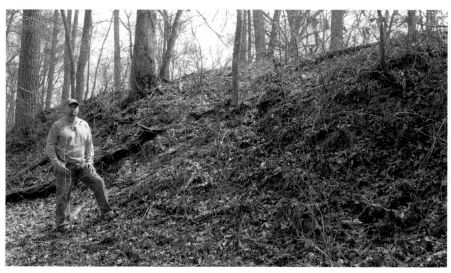

The author is pictured beside the lower portion of the Old Stone Fort wall along Duck River. Most archaeologists believe the "fort" in Manchester in Coffee County was built by ancient native peoples to enclose a ceremonial site. Others consider the stone fort to be the work of legendary twelfth-century Welsh adventurers. *Photo by Stephanie Guy.*

Were they left by a twelfth-century band of Welshmen who were eventually absorbed by Native American tribes? Or is there some other explanation?

Today in Alabama's Mobile Bay there is a marker placed by the Daughters of the American Revolution commemorating the landing of Prince Madoc at Mobile Bay in the year 1170. While the legend remains, evidence is thin. But in this piece of hidden history is the possibility of white Welshmen who saw the beauty of East Tennessee three hundred years before Columbus set sail.

Granny Ward's House

She was already old when she moved out of the cabin on Mouse Creek, just north of the Hiwassee River. At perhaps her eightieth year, she was considered the oldest person among the Cherokee. Over the course of her life, she had seen her people transform from a tribe of mighty warriors to simple farmers, from allies of the British to a people conquered through treaties by the Americans. She had always done her best to promote peace with the whites; she had once been married to a white trader and had borne half-Cherokee, half-white children who now had children and grandchildren of their own. The world they would grow up in would be very different than the one she had known so many years ago.

Once, she had been very beautiful and had been the object of much talk and admiration among both Indians and whites. She had known great men, both Indian and white, and had sought only peaceful relations between the two. But in her quest for peace, many of her own people had forsaken her, believing her to be a pawn of the whites. Certainly, she had saved many whites from death, once even taking a white woman from the burning post. But she had always

done what she thought best for her people. The whites, she had always known, would always be more powerful than her own people. It had been a bitter thing to swallow, but she had accepted this long ago. Still, many of her own nation did not believe it. How sad it is, she thought.

She had moved to her little house on Mouse Creek in 1817. Her relative, Jenny McIntosh, had it built for her to give her a place to live in her old age. Now it was 1819. A new county called McMinn, named for the governor, had been formed around her from lands her people had sold to the Americans. The American government was sending its agents to the Cherokee, trying to convince them to move west, to finally give up all claims to their lands in Tennessee and Georgia. She listened to the impassioned talks of her relatives. Some were for moving, others were not. Many times the arguments grew harsh, but she paid little mind to such things. She knew that her time drew short. Others may leave, but her bones would rest here, near those of her fathers.

Even now, she remained strong. She still worked in her small garden, and she would often sit and watch her grandchildren play around her, or take short walks to the McIntosh home nearby. She seemed happy, but she was not.

More and more, her family was embroiled in arguments. We should move away, some would say. No! We must stay and fight the plans of removal, others would argue back. Argue and argue. There was no peace at home. Peace, the one thing she cherished. She was too old for such strife in her own family. And lately, the disputes had been between the McIntoshes and their neighbors, the Gardenhires. It had become more than the old woman could take.

Against the wishes of her kinsmen, she made her decision. She would move away. Her son lived a little way southwest, at a ford over the Ocoee River called Woman Killer Ford. She sent for her son, Fivekiller. He was an old man now, but he came to his mother's aid, along with her grandson-in-law, Caleb Starr. They put her few things in a wagon, and she left forever the cabin on Mouse Creek in newly

At the base of the hill below Nancy Ward's grave is Woman Killer Ford, where the Great Indian Warpath (and later the Old Federal Road) crossed the Ocoee River. *Photo by Stephanie Guy.*

formed McMinn County. Fivekiller had a small house near his own on a hill overlooking the Ocoee. She was welcome there, he told her. It would be a quiet place to live, he had said. She had laughed within herself. She only wished for a quiet place to die.

A few years later, in 1822, Granny Ward closed her eyes for the last time. She had grown old and ill, and was at Fivekiller's home when she passed. Legends would come later of a bright light that rose from her body and flew off toward the place of her birth. But it was only a tale. Her family buried her on the hill directly in front of her home, overlooking the river ford.

Years later, descendants and students of history would honor Granny Ward with a monument placed over her grave at Womankiller Ford in Polk County, so that future generations would remember her contributions, both socially and politically, to white-Cherokee

The grave of Nancy Ward, beloved woman of the Cherokee, south of Benton in Polk County, Tennessee. Buried alongside her are her brother, Longfellow, and her son, Five Killer. Her house was also located on the same hilltop to the rear of the photo. *Photo by Stephanie Guy*.

relations and to Tennessee's early settlement and history. Nancy Ward's 1817–19 home in McMinn County was largely forgotten, but she is mentioned in William G. McLouglin's *The Cherokee Ghost Dance* as having "lived one mile below John McIntosh on Mouse Creek." Much of the information in forgoing narrative regarding her house in McMinn County and her decision to leave it is based on information in *Nancy Ward v. United States, Claim #36*, in *Cherokee Reserves*, edited by David K. Hampton.

The Great Warrior

During the archaeological excavations of the Cherokee town of Echota (Et-sa'-tah in the Cherokee language) on the Little Tennessee River in the 1970s, a peculiar grave was found. It was of a man, about six feet tall, and the remains were badly degenerated. The grave was unlike any of the others, for the man had been buried in a makeshift coffin, and beside him were a knife and a pair of spectacles. The discovery caused quite a bit of excitement, for the archaeologists were almost certain they knew the man's identity: it was Oconostota, great warrior of the Cherokee.

Oconostota (Agana-stata: "groundhog sausage") was born around 1710, and little is known of his early life. It is certain, however, that he adopted the life of a warrior. By the time of the great smallpox epidemic in 1736, he was a grown man, tall and athletic. Legend has it that he was considered handsome before the smallpox came, but both his face and his heart were terribly scarred by the disease that had come from the whites. Like many Cherokee, he never forgot the source of his troubles.

By 1750, Oconostota had attained high status within the tribe, and held the office of "great warrior," essentially the war chief of the nation. He was a well-respected war leader, careful and vicious in his attacks on other tribes. It was commonly told that he never lost a man in battle, which literally made him a legend in his own time. He was not known for his oratorical abilities, but he would and did speak on several occasions in Cherokee councils or at meetings with whites. He was conscious of the power of his own tribe, but had many times seen the soldiers and warships of the British in Charles Town in South Carolina, and although he sometimes courted the French, he recognized the military might of the English.

By 1756, he had become a fast friend of the English and enjoyed their trade, which brought muskets, lead and powder to his warriors. He was present as the British built Fort Loudoun in the heart of the Cherokee Nation, and more than once led war parties against the

Shawnee and French on the British settlers' behalf. He resided at the Cherokee capital at Echota.

But in 1759, some disaffected young warriors under the influence of a Creek chief, Mortar, and a French spy named Lantagnac made an attack on the North and South Carolina frontiers. The South Carolina governor, William Lyttelton, halted all trade with the Cherokee until the guilty warriors be turned over to him. Oconostota, along with several other chiefs, went to Charles Town in an effort to keep peace. But Lyttelton placed the chiefs under arrest and marched them back to Fort Prince George in South Carolina as hostages. Oconostota was released with the help of the Cherokee peace chief, Attakullakulla, and soon afterward appeared before the fort walls. After luring out the commander, Richard Coytmore, Oconostota gave a signal. Several hundred Cherokee opened fire on the fort and those inside attacked the soldiers with knives and tomahawks they had hidden. Coytmore was killed, as were all the Cherokee prisoners inside. A furious Oconostota immediately declared war on the English, laying siege to Fort Prince George and Fort Loudoun, and placing warriors at all mountain passes between the Overhill country and Charles Town.

The British authorities responded immediately, sending Colonel Montgomery with a detachment of Royal Highlanders into the Cherokee country. Oconostota and his warriors ambushed them near present Franklin, North Carolina, forcing Montgomery to retreat. Slowly, Fort Loudoun succumbed to the siege. Its inhabitants attempted to march back to Charles Town, but were attacked and made prisoners near Tellico Plains, as the Cherokee believed the surrender terms had been violated. The following year, Oconostota led another attack near Franklin against Colonel Grant, but was defeated. The Cherokee, weakened by a lack of food and trade, agreed to a truce in 1761.

Oconostota, along with Attakullakulla, became the de facto chief of the Cherokee. In 1775, as an old man believing it less harmful to sell land than fight anymore, he agreed to sell most of present-

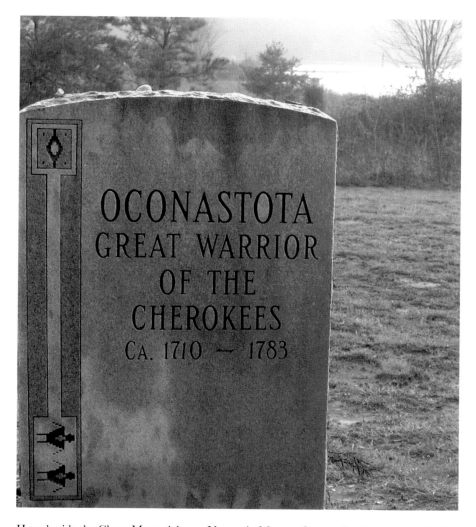

Here, beside the Chota Memorial near Vonore in Monroe County, lies the greatest of all Cherokee war chiefs. Oconostota died in 1783 and was buried in his canoe in the doorway of the Chota council house. His remains were discovered by archaeologists in the 1970s and reinterred here after the construction of Tellico Lake. *Photo by Stephanie Guy.*

day Kentucky and Middle Tennessee to Judge John Henderson at a meeting near present-day Kingsport. During the Revolution, with the Cherokee siding with the British, American forces under John Sevier drove through the Overhill towns, leaving Oconostota and his people

to live in the forests. Again, the Cherokee were forced to a truce and more land sessions, this time with the Americans.

In 1783, while living with Nancy Ward on the long island of the Holston, the old warrior felt his time approaching. He was taken by canoe back to Echota by Nancy and her son-in-law, Joseph Martin. There Oconostota died and was buried in the entrance to the council house; the canoe he had traveled in was his coffin.

When his body was identified almost two centuries later, he was reburied at almost the exact spot at the Chota Memorial east of Vonore, under a headstone reading: "Oconastota, Great Warrior of the Cherokee."

GHOSTS, GRAVES AND
STRANGE HAPPENINGS

There are some things in the historical record that are simply too strange, too coincidental or too unbelievable to be true. Certainly, some stories are only legends and old wives' tales, having grown with every telling over the years. But other stories are best taken as they are…

A Grave of Ice, a Grave of Fire

The Dry Pond Lead Trail off Highway 64 in Polk County, Tennessee, is a popular hiking and hunting location for outdoor enthusiasts, located on the edge of the Little Frog Wilderness in the Cherokee National Forest. From Highway 64, the trail runs north some 4.5 miles over rough mountain terrain to the Old Kimsey Highway.

Just east of where the trail meets Kimsey Highway is a place called Jenkins Grave Gap. There in the lonely mountain gap are two graves, separated by forty years but connected in a horrible manner. For many decades, stories have existed regarding the location and its supposed haunting. But even the truth of the matter is strange enough.

In 1854, few good roads existed in Tennessee, especially in the mountainous region of Polk County's east side. The new Copper Road

through the Ocoee River gorge had only been completed the year before, and many people continued to travel from Benton to Ducktown over the Little Frog Mountain Trail, which followed an old Indian trail. The route was difficult, as it passed through deep hollows and over high ridges, but this was at the time the most traveled connection between the two sides of Polk County. It was also the route that the mail carriers used. At certain times of the year, the lonely trail was a dangerous place to be.

In February of 1854, a mail carrier named Thomas Jenkins left Benton and started on his mountainous route to Ducktown, a trip that would have taken an entire day. Following the trail higher into the mountains, Jenkins began to encounter snowfall that piled deeper and deeper the farther up he went. When he failed to arrive in Ducktown that night, it was feared he'd fallen into trouble. No one knows what happened for sure; possibly he stopped to wait out the weather, or he became delirious in the cold, but days later his body was found in a gap along the trail. He had frozen to death. So remote was the place that Jenkins was buried in the very gap in which he had died, and the place became known as Jenkins Grave Gap.

The trail became used less and less often as the new Copper Road was improved, and even the mail carriers began using the new road to Ducktown. For the next several years, more families moved into the Little Frog area, one of which was the James Morgan family.

In 1897, the Morgan family was burning off an area of their property. It was a common practice in those days, as the burned-off areas made it easier for livestock to forage on the forest floor for acorns, hickory nuts and chestnuts. But the Morgans' small fire roared out of control, and one of the Morgan daughters, Elizabeth, was caught up in the inferno and burned to death. Since the family lived only a short distance from the Jenkins grave, it was determined to bury their daughter in the same gap near the ill-fated mail carrier.

Strangely enough, the lonely gap remains the gravesites of two extreme deaths: one a victim of ice, the other a victim of fire. The tragic stories gave birth to ghost stories still told today around campfires in Polk County.

When the Copper Road fell into disrepair in the early twentieth century, the Little Frog Trail was improved in 1920 at the behest of Dr. L.E. Kimsey, and for a time flourished as the Kimsey Highway until the Copper Road, present Highway 64, was improved in the 1930s. Kimsey Highway is still used, though mainly by hunters, hikers and the U.S. Forest Service. At Jenkins Grave Gap it is still possible to find the Jenkins and Morgan headstones today, though they are severely overgrown with vegetation. The only way to find them is to search in the light of day, for the gap is dark and unfriendly at night; a place where fire, ice and death have a strange and ominous connection.

Mrs. Leonard's Body

While a student at the University of Tennessee during the early nineties, I was fortunate to have been a student of Dr. William "Bill" Bass. Dr. Bass is a nationally recognized forensic anthropologist whose area of research includes studying how human bodies decay under different circumstances and how to identify bodies that have been reduced to skeletal remains. While this sounds morbid, it must be understood that Dr. Bass has made so many advances in this type of study that hundreds of homicides have been solved due to his work. Bill Bass is widely known and respected among police detectives.

As a student in one of his classes in college, I quickly found out that Dr. Bass's classes are unlike any other. One thing in particular was that the mummified upper portion of a human body was used to teach students the effect of embalming and how to identify cemetery remains in a forensic setting. The remains were from an elderly female whose last name was Leonard.

Mrs. Leonard's body consisted of her head, torso and upper right arm. She resembled the "skin and bones" look of an Egyptian mummy.

When this body was found on the banks of the Hiwassee River in McMinn County in the early 1980s, law enforcement officers feared they had a murder victim on their hands. But the trained eyes of Dr. Bill Bass told a different story: "The presence of hair, eyebrows, eyelashes, and the dry skin on the face were common in embalmed bodies that have been buried for some years." *Courtesy Dr. Bill Bass and University of Tennessee Anthropology Department.*

Being curious college students, we took several opportunities to view Mrs. Leonard's remains up close, and would listen as Dr. Bass told her story.

It seems that Mrs. Leonard was the wife of one Dr. Leonard, and they lived during the 1800s in the area of Jalapa in Monroe County, Tennessee. He was a well-known physician, and records abound regarding his practice. After the Civil War, he performed many exams on veterans seeking war pensions; my great-grandfather, Andy Morgan, was one of them. Dr. Leonard was a bit eccentric in his old age, and before he died he had a mausoleum built to house his and his wife's final remains. He had placed on the door a curt and odd message, which read simply, "Leave Me Alone." According to their wishes, Dr. and Mrs. Leonard were laid to rest in the mausoleum after their deaths in the late 1800s.

But as the years went by, the mausoleum fell into disrepair. A hole appeared in the rotted roof that allowed curiosity seekers to climb on top and look down on the two coffins inside. Someone even took stones and broke out the glass top of Mrs. Leonard's casket, giving a full view of her mummified body. To a lot of young people in Monroe County, the Leonard mausoleum became a much-visited attraction on dark, scary nights.

On one such night in the early 1980s, the McMinn County Sheriff's Department received a call that a body had washed ashore on the banks of the Hiwassee River. On their arrival, officers did indeed find a corpse lying on the riverbank. The body was in a late stage of decay, and had a large logging chain wrapped around it. Officers quickly secured the scene and began an intense investigation into who the victim might be and how they had been killed. The signs pointed to either a homicide by drowning or a homicide victim's body

Dr. Bass quickly pointed out to the police the "white area on the back of the skull, which indicated that the head lay on a wet pillow in the coffin, causing skin to decay." It was clear the body had been stolen...but from where? *Courtesy Dr. Bill Bass and University of Tennessee Anthropology Department.*

having been dumped into the river. Authorities from nearby Polk and Bradley Counties, as well as the cities of Calhoun and Charleston, also became involved. Several theories began to develop, some officers even speculating that the person was a victim of some sort of "satanic ritual." Realizing the difficulty in identifying the victim, the officers contacted Dr. Bass at the University of Tennessee.

Early the next morning, Dr. Bass arrived with his team of assistants. He listened patiently as the officers told him what they had found, as well as what they thought might have happened. Dr. Bass walked down to where the body lay and, kneeling down, took several minutes simply looking over the scene.

One of the detectives, unable to wait, said, "Well, Doc, how long ago do you think the time of death was?"

"Oh," responded Dr. Bass, "I'd say, give or take, about eighty or ninety years ago."

The detective wasn't sure he'd heard correctly. "But Doc, how do you think this person died?"

"Well, it's really hard for me to draw that kind of conclusion," answered Dr. Bass. "But I'll tell you one thing: this person has been in a coffin for a long time."

The detective couldn't believe it. "You mean this person didn't drown?"

"Not in this century," quipped Dr. Bass. He then showed the officers the small piece of cotton sewn into the victim's neck where an embalming procedure had been done, and then rolled the body over to reveal a circular place on the back of the skull. "This is where the head rested against the pillow in a casket. I would imagine we have a case of grave robbing here. Somebody is pulling your leg with this 'body in the river' thing."

Later, it was discovered that in nearby Monroe County, a body had been stolen from an old mausoleum. The body was, of course, that of Mrs. Leonard. And so it was that some vandals pulled a macabre prank that almost fooled the police into believing that a murder had been committed. But the officers had luckily decided to request the assistance of a man who knows dead people better than anyone.

Even after she was identified, Mrs. Leonard's remains were kept at the UT Anthropology Department, because no one really knew what else to do with her. She became rather well-known among anthropology students, and the fact that I came into contact with the body of a woman my Civil War ancestor knew personally has always intrigued me. Finally, some of the Leonard descendants requested that Mrs. Leonard's body be returned so that she could be reburied with her husband. But Dr. Bass, I recall, had mixed feelings.

"I really hate to see her go," he told us. "I've actually grown quite fond of her."

The Night the Stars Fell

The night of November 13, 1833, was clear, moonless and starry. All over the Southern United States, residents went about their evening chores and prepared for bed. There were no streetlights or gas lights then, and even the larger towns such as Athens and Knoxville in East Tennessee were only a few years removed from their frontier days. Except for firelight flickering in the hearths of houses and taverns, the darkness of night enveloped all in primordial blackness.

It was a time of great change, with an increasing amount of religious fervor in the region as churches became established and pushed for the improved morality of their members. Another of the most intriguing social issues was the Indian question: should they be removed from their ancestral lands to other less-inhabited areas west of the Mississippi? Even the Cherokee themselves were not unified on the answer, as some refused to consider selling their lands and homes, while others saw the west as a place of great opportunity for their people.

And so that September night, with so much on the minds of so many, a pleasant night's sleep was suddenly interrupted. In the country,

farmers pulled their families outside and pointed to the sky. In the towns, fearful crowds poured into the streets as people shrieked and prayed, terrorized by what would become known in later years as the "night the stars fell."

It began around 10:00 p.m. Without warning, the stars began to fall all across the dark sky. At first it was one or two, but the display increased until the entire night sky was filled with up to thirty stars streaking across every second. Many were described as being as large as the moon itself, and would burn with such intensity as to light up the sky as if it were day. To some terrified spectators, many of the stars seemed to actually touch the ground.

People all along the eastern seaboard were witnessed the event. A Boston newspaper reported that meteors fell "as the flakes of snow in one of our common snowfalls." A Missouri paper said the sky "was filled at every second with falling stars." In Annapolis, Virginia, the lights were so bright that many ran outside, fearing their dwelling places were on fire. None of those who saw it had ever witnessed such a thing in all their lives. As the lights flashed and burned, many took it for a sign. In Athens, Tennessee, residents went running through dusty town streets calling for all to come out and repent, believing that the end of time had come. It was commonly reported that many fell to their knees confessing their sins in what they considered were the last moments they would enjoy on earth. As the flashes of light increased, so did the sounds of earnest prayer and shouting. Women cried, children wept and men shook in their boots, recalling the words of Revelation 4:13: "And the sun became black as sackcloth of hair, and the moon became as blood, And the stars of heaven fell unto the earth."

For thousands of slaves across the region, the falling stars also seemed to indicate the end of the world. But the slaves enjoyed an added benefit: many of their white owners gathered their slaves together and told them who their mothers and fathers were, to whom relatives had been sold and where they were now living. The slaves were happy to hear such previously guarded information from whites who wished to clear their consciences before Judgment Day dawned.

The Cherokee Indians also witnessed the event, and like so many others, considered the stars to be a bad omen regarding their troubles with the state and federal governments. Such natural signs were tied to a host of bad memories, including the Creek Wars twenty years earlier. With their eyes to the skies, it seemed clear that indeed their end was near.

The stars fell with greatest intensity until about 1:00 a.m., and then sporadically burned across the sky until dawn. Many people sat up all night to watch for the new sunrise in the east, waiting with a fearful dread for the angel bands and heavenly hosts to certainly fill the sky.

But alas, there was no trumpet, no earthquakes, no end of the world. Life went on, although with a renewed sense of the wonders of nature. But the night was burned into the memories of thousands of people who for the rest of their lives would relate the horrors of the night and the impending doom that so many people felt was near. Songs were written about it, such as "Stars Fell on Alabama."

The event so impressed some that they literally marked time around it. Twenty-four years later, while taking testimony in McMinn County Chancery Court, it was recorded of "old man Lankford who lived on the land and who died there…the year the stars fell."

Here, There Be Witches

When Halloween approaches, witches begin to grace the streets and storefronts of our area. They are in the form of masqueraders attending parties and trick-or-treating, or they're seen in paper decorations of windows and store aisles. The witches are, of course, dressed in black, complete with pointy hats and striped stockings, no doubt with black cats close by.

But such a character of a witch was not always so around here. Years ago, the image of a witch was less menacing and much more like an average person. In fact, people were much more suspicious of "witchery" prior to the mid-twentieth century, and just about any person might be suspected of such nefarious behavior.

Older, single women, spinsters as they were often called, fit easily into the image of a witch, especially if they ever exhibited any strange behavior. But often it was not the person, but a series of events that brought about the suspicion of being a witch. For example, should several of a farmer's livestock die, a crop not produce, a pot not cook food right or even a gun not shoot straight on a hunt, it was commonly accepted that witchcraft was behind it.

But there were "cures" for these suspicions. Pots that were considered "spelled," for example, were supposedly cured if the woman of the house whipped the inside with a length of thorny briar. Guns that were considered to be "spelled" were required to have the barrel removed and placed in a clear-flowing stream for a day or so. The idea was that such treatment would "wash" the spell out of the object. Also, a hunter might trick a companion into borrowing some patching or bullets, and thereby pass the spell of his own gun to that of his companion. Clear-flowing water was a standard remedy to rid a person or item from witchcraft, as it was told that a witch could not cross such a stream.

Stories of witches were common, even locally. A story was told as late as the 1960s of an old woman who visited a farm in the Calhoun area of McMinn County, asking for something to eat. She was taken in by the family, but was told that that the pitcher was empty and there was no milk in the house. The old lady asked for a pewter fork, which she took and placed in the puncheon boards of the dining table, muttering some strange words. When the milk pitcher was checked again, it was found to be full. However, the trick was said to be two-sided, for after the old woman had left the next morning, the farmer went out to milk the cows. To his horror, he found their udders dry and unable to produce any milk at all.

Fearing his family was cursed, the farmer set about correcting things. He secretly melted down his silver ring, making a silver bullet. He then

It was believed by many pioneers that placing a "witched" rifle barrel in a clear stream would break the spell and allow the gun to shoot straight again. It was also believed that a witch could not cross a clear-flowing stream. *Photo by Stephanie Guy.*

prepared a small effigy of the old woman and hung it on a fence post. Taking careful aim with his old rifle, he shot the effigy through. He had just returned his gun to the mantel when a neighbor came running. It seems the old woman had approached the neighbors' family, once again asking for something to eat. But suddenly she had grabbed her chest as if struck, and had died on the spot.

Of course, such stories are old and far-fetched, from a time long since past. Our fast-paced world reserves such tales for campfires and October nights, when our imagination is as relaxed as the leaves drifting from the trees.

Then again, I've noticed my gun is not shooting straight and my garden didn't seem to do very well this year. I wonder if the waters of Burger Branch are still running clear...

Food and Grief

I lost my grandparents a few years ago, both within a year of each other. It was a blow to our family, but in some ways it was expected. Neither had been in good health for a long time, and the toils of old age had begun to take away from their quality of life. My grandmother passed on in August, never truly getting over the loss of my grandfather the previous January.

Like most people, there are certain relatives I never see unless there has been a death in the family. That year, I saw some of those people more than I had in a long time. In addition to the funeral home, several relatives also paid a visit to my grandparents' home, where the family had gathered with close friends and neighbors. And everyone who came brought food.

This particular custom is well-known throughout the South, and probably observed here more religiously than in other places. Not so many years ago, funerals were held at the home of the deceased. I am told that people didn't just come and visit the family; they stayed for several days. A wake was generally held the first day and night, as it was believed that this provided the family enough time to make sure the relative was indeed not going to "wake up." I've also been told that doors were made large in most houses to be able to accommodate a coffin. The funeral and burial in a nearby cemetery would follow shortly thereafter. Since the visitors often stayed, they of course brought food.

This tradition continues, as it did when my grandparents passed away. The amount of food overloaded the kitchen table, and included innumerable pies and cakes, two hams, Jell-O salad, several cold cut and cheese trays, assorted vegetables and the customary bucket of chicken. There was more than enough for our large family, and we invited all of

In this photograph from around 1900, Darius Daugherty watches while his wife, Callie, washes and prepares the body of their deceased child for funeral and burial in the Burger Branch Community in McMinn County. A traveling photographer had stopped at the Daugherty residence just after the child had passed away, and took this rare photograph. *Author's collection.*

the guests to eat as well. The dishes were carefully catalogued by my mother and aunts as they arrived so as to be able to return them to the respective guests.

The offerings of food went a long way to express the condolences of friends, neighbors and relatives. Those evenings were a rare opportunity to catch up with one another, see new children and talk about times long past. After the funerals, it was even more comforting as we went back and ate once more with our loved ones, glad the business was over and ready to get back to our lives while dealing with our loss. Such an occasion was described in better words than mine in an article by Mr. John Egerton published in the September 2002 edition of *Appalachian Life Magazine*: "When the funeral was over, the family invited relatives and out-of-town guests to join them at the house. There, on the porch and lawn and in the kitchen, the food that so many caring people had

brought was spread before the throng, and a sad occasion ended on a happy note of fellowship and remembrance."

Spooks, Anyone?

"Do you know of any haunted houses or ghost stories?" This question comes often around Halloween. People ask with a mischievous look in their eyes, as if they want to learn some secret tale not meant to be told. As I have said before, I am not entirely a "believer," although I enjoy a good ghost story and enjoy even more a visit to a supposed "haunted" place.

I do collect ghost stories as they come up during the course of research and talks. In fact, there are several houses and sites in the area that are rumored to contain some sort of "haint." Again, these are related as they have been told to me. I've never actually observed any of these—well, maybe a few, but that's for another story.

It has long been told that the Cleage House on Highway 11 near Niota is where the ghost of an old man with a long white beard would appear and rock silently in a rocking chair. There is also a story of a bloodstain on the floor that was told to be that of a Union soldier killed by one of the Cleage slaves during the Civil War as he tried to rob the house of food. No matter what has been done to remove the stain, it always comes back. Another old house off Highway 307 between Englewood and Niota had a mystic resident. Although the house was deserted, several people have told that if you went inside the living room an old man would shuffle in and have a seat in an old rocking chair, and then disappear.

There is a well-known tale in Charleston of an old doctor who always desired to have a skeleton to hang in his office. This doctor treated the victims of the great train wreck following the bridge

Samuel Cleage had traveled south from Botetourt County, Virginia, building brick homes and public buildings along the way. He settled in McMinn County and built this house just south of Mouse Creek (now Niota) around 1835. Several ghost stories are associated with the old house. *Photo by Stephanie Guy.*

collapse into the Hiwassee River in the later part of the nineteenth century. One of the severely injured was a young Jesuit monk. After the accident, the old doctor was known to have a skeleton that hung in his office for many years. Long after the doctor had died, his house was being torn down, and inside the walls were found a monk's habit and a string of rosary beads.

Not everyone is proud of their "ghosts," and they prefer to remain unnamed when they report events that can't otherwise be explained. There is a particular house in Englewood where at least one mysterious death occurred some thirty years ago. Since that time, strange stains appear to soak though the floor, and when attention is drawn to the sound of footsteps on the stairs, no one will be there. Unclaimed clothing

The Cate House in Niota, Tennessee, with the old slave cabin visible just to the right beyond the fence. The home was built by Samuel Cleage around 1840. *Photo by Stephanie Guy.*

Past property owners have told of seeing glimpses of a little black child running around the old slave cabin behind this pre–Civil War house. The ghost of a slave child perhaps? Or simply a figment of active imaginations? *Photo by Stephanie Guy.*

is occasionally found on the floor, and other unexplained things occur. The owners, of course, wish to remain anonymous for various reasons.

Some strange tales also surround a historic home in Niota. The house, built prior to the Civil War, once had slave houses that sat nearby, one of which still stands. At times, owners have caught glimpses of a small black child running barefoot around the old slave house, even though no one lives there and no child or tracks have ever been found around the building. Also, the ghost of a Confederate courier is said to haunt the back side of the farm near an old spring. Years ago, the spring was surrounded by quicksand, and when the courier was being pursued by some Union soldiers, he became entrapped. According to the story, the Union soldiers stood by, taunting the young Confederate, as the quicksand held him fast and slowly claimed his life.

Of course, Brock Hollow (properly spoken as "holler") over in Englewood has long been the scene of strange sightings that surround the story of a man who was robbed, tied to a tree and killed after a card game went wrong. Other stories surround objects such as trees, bridges and mountains. In the late 1800s, the tale was commonly told of the "Star Mountain Haint" that struck fear in travelers across the mountain's dark coves. My grandmother remembered the tales and recalled her father telling of an eerie yellow light that drifted alongside him as he rode a horse along the foot of the mountain one dark night.

I could go on, but space is limited and there are just too many tales to tell. Eventually, I'll have to turn off the lights and go to sleep. Although I may not entirely believe, I also think it best not to stir anything up in the retelling of too many old tales. There are some tales better left untold.

TRADITIONS

We take traditions for granted, assuming that what we practice today is the way it has always been. But holidays, medicine and even death have been observed in different ways over the years, and the stories behind our present traditions make for some rich history.

A Hidden History of Christmas

December 25, 1789, was the first Christmas under America's new constitution. And while some 215 years later our legislators will be spending that time at home with their families, our first Congress was actually in session that late December day. Christmas was considered at the time to be an "English" holiday, and as such was not officially observed. Christmas would not be declared a federal holiday until June 26, 1870.

Earlier still, the celebration of Christmas was often outlawed. Many Puritans believed that the celebrating and decorating were not proper. In Boston in the late 1600s, any person exhibiting the Christmas spirit was fined five shillings. There were some celebrations of the day, such as in Jamestown, which involved a gathering of people and a great feast.

A time of celebrating in late December goes back thousands of years. Early Europeans believed that as the winter days grew shorter and the nights grew longer, the presence of evil spirits increased with the increased time of darkness. So they celebrated the winter solstice to welcome the return of the sun and longer daylight. The Mesopotamians and Persians also celebrated and worshiped their gods around this time of the year. The yuletide was a Scandinavian celebration of the same type, which involved the ritual burning of the yule log and feasting until the log was consumed. There was also the tradition of hanging apples and other dried fruit from a tree to signify the return of spring.

Later, the Romans celebrated what they called Saturnalia, or the festival of their god Saturn, which ran from the middle of December until the New Year. This involved a great time of feasting, parades, parties and the giving of "good luck" gifts. As Christianity spread, the observance of such decadence was frowned upon. In an effort to sway attention away from festivals such as Saturnalia, in AD 140 it was decided to observe the birth of Christ during this time with a solemn day of remembrance. But the old traditions of feasting and revelry continued until they were finally accepted around AD 350, thus placing a more "Christian" label on the events while still keeping many of the traditions. Still, many Christians chose not to keep such a religious holiday.

Christmas traditions continued on and off throughout Western Europe, some years being accepted and at other times being condemned. But traditions of feasting, decorating with greenery and some kind of celebration were kept throughout the Middle Ages and into the 1400s. Few of these holidays were to remember the Christ child; to most they were simply times of revelry.

Such traditions made their way to the New World during the age of discovery, but like the examples of Boston and Jamestown, different groups observed the day in different ways, or not at all. An overly bawdy 1827 Christmas riot in New York caused that city to form its first police department. As late as the early twentieth century, it was not unusual to celebrate Christmas with fireworks and gunshots, which was especially common in rural areas such as Appalachia.

The writings of Washington Irving are credited with literally creating the holiday that we call Christmas in the early 1800s. It was during this time of social class conflict that Irving wrote stories of Christmas being a time of gathering together, of good will toward our fellow man and of peaceful sharing with others. Irving was writing to change the social consciousness, and his "creation" of a wholesome Christmas holiday is evidence of his success.

The familiar images of Christmas, as it is known today, did not appear until after the Civil War. Santa Claus began to appear with a red suit, beard and a bag of goodies. Decorated Christmas trees started as a Victorian-era fad that was spread all over the country through pictures in magazines.

It was also during the Victorian age that the American family became less disciplined. More attention was given to children, and Christmas was the perfect opportunity to provide both a moral story as well as a time of magic for little ones. Over time, old traditions were unearthed and reworked, and with the support of many churches the season of festivities was given over to the birth of Christ, while at the same time including Santa Claus, the decorating of trees, sending Christmas cards and giving gifts. The family Christmas dinner replaced the often decadent Christmas feast. By the middle of the twentieth century, much of the world had adopted America's version of Christmas.

While it is easy to assume that our current celebration of Christmas is the way it has always been, we are actually celebrating a holiday that has evolved over time, only to be reinvented by the social needs of America.

Ms. Daugherty's White Hat Christmas

His name has been lost to time, but for the sake of this story we will call him Tom Daugherty. Tom lived with his widowed mother in rural

McMinn County in the Nonaburg area, where narrow low-lying fields wrap around steep ridges, leaving little flat land to farm. Tom's father had died several years earlier, and although his mother had done her best to instill some raising in Tom, he had grown into a bit of a rebellious young man. Farming and its associated labors did not suit Tom very well. He was much more fond of spending his days lounging around the house, sleeping off the previous night's moonshine he'd drank with his friends in some dead-ended hollow.

Ms. Daugherty worked her fingers to the bone, with little help from her son. As he was her only child, she overlooked his many faults as she cooked meals, cleaned their ragged house, washed their clothes, grubbed their hillside garden, fed their livestock and labored at too many other chores for a woman her age. Neighbors whispered about Tom, and more than one of the men who passed him walking on the dusty trail through Nonaburg and Burger Branch remarked that a decent son would take better care of his mother. But Tom was unmoved, and normally sneered at anyone who tried to steer him back to his responsibilities.

The year was 1930. The entire country was deep in a financial depression, with businesses failing and millions of people out of work. But in rural areas like McMinn County, many of the poor farmers could tell little difference. They continued to raise their crops and work their land, some hunting and trapping to keep food on the table and to provide hides to barter with at the local store. Their world consisted of their farm and their neighbors, and so long as that world was taken care of, they had little time to worry about anything else. In those days, neighbors looked out for one another.

And so it was with increasing disdain that the neighbors regarded Tom Daugherty. As the cold weather blew in with December, it was well noted that while everyone else around had a good supply of firewood to last the coming winter, old Ms. Daugherty's porch had only a small pile of wood, and that being what she herself had cut and hauled out of the ridges. It was well-known that Tom enjoyed the warmth of a hearth that he had not created himself.

One night, not too long before Christmas, Tom was sleeping off the day's jug of shine when he was shaken out of his sleep. Many strong hands dragged him from his bed, threw a cover over his head to blind him and took him outside. He cried out for his mother until he remembered that she had gone to Athens to visit her sister. He tried to fight back, but there were too many of them. Roughly, they pulled him into the yard, and when they tore the veil from his face he couldn't help but scream. The White Hats had come for him.

There were between fifty and sixty men surrounding him, armed with torches and an assortment of rifles, shotguns and pistols. Each man's face was covered in a white hood that looked to have once been a pillowcase or sack with eyeholes cut in the front. Tom knew immediately what was happening. He had heard of the White Hats before, but only in the rumors and tales of the area. It was said that they had visited others in the neighborhood who needed "persuading," and there were stories of things that had been done. He knew the men who now held him were his own neighbors, which caused him to fear them even more. Suddenly one of them spoke.

"Tom Daugherty," said the leader of the men, who brandished a large axe, his voice muffled by his shroud. "We are the White Hats."

"What do you want with me?" Tom squealed.

"You are a vile man, Tom Daugherty," said the leader. "Your daddy was a good man. And your mother keeps you up, and you treat her like a slave."

"No!" Tom cried. "I love my Mama!"

"You lie!" said the leader, pointing to the few pieces of firewood on the front porch. "You don't care if she freezes to death. She barely has a stick of wood. You're a bad son, Tom Daugherty, and time's about up for you." The men who held him jerked him around and dragged him over to the pile of wood where his mother worked to split the large pieces into those small enough to fit into her wood stove. They threw Tom down on the pile as the leader approached him with the axe. Standing over Tom, the man raised the axe over his head and swung

downward as Tom screamed. The axe blade buried itself in a large chunk of wood only a foot from Tom's head.

"You better get to cuttin' wood boy," the leader snarled.

It was told for years afterward that Tom Daugherty sawed and chopped wood that night, barefoot and in his nightshirt, as the light from the White Hats' torches burned around him. They say he whimpered like a baby, but that he chopped and cut wood like a man possessed. As morning dawned, he was thrown back into his own bed, where he collapsed.

And it is also told that by that Christmas, and for every winter thereafter for the rest of her life, old widow Daugherty had more split firewood on her front porch than anyone else in the hollow, and that her farm was the envy of all her neighbors, all kept up by her hardworking son, Tom.

Goodbye to the Old Long Ago

As we pass the black-eyed peas and hog jowls around our Southern dinner tables each New Year's Day, it is interesting to consider some of the reasons why we celebrate the New Year in the first place. To answer such a question, we have to look back some two thousand years, understand the calendar we use and know something about pigs.

While the celebration of the new year is perhaps the oldest of all holidays, it has not always been celebrated on January 1. It was first observed in ancient Babylon about four thousand years ago, and took place in mid-March at the vernal (spring) equinox. The Egyptians and Persians celebrated a new year at the fall equinox, and to the Greeks the new year came at the winter solstice. It was largely a celebration of the end of winter and the coming of summer, or vice versa.

Celebrations of a new year evolved over time to be held after the winter solstice, with a new spring growing season just around the corner. The Romans celebrated the March new year until Julius Caesar established the Julian calendar and firmly established January 1 as the first day of the calendar year. It was purely arbitrary, with no astronomical or agricultural significance. The beginning of spring is a logical time to start a new year.

The ancient Babylonians had quite a new year celebration, as it lasted for eleven days. The revelry that took place in Babylon makes modern parties pale in comparison. Mixed in with pagan symbolism and beliefs, new years' celebrations were once condemned by the churches. It has only been for the past four hundred years that Western nations celebrated January 1 as a holiday. New holidays were created to combat the pagan celebrations, such as celebrating the new year as the "Feast of Christ's Communion." It seems placing a more appropriate name on the day made people feel better about their celebrating. Other cultures built bonfires signifying the destruction of the old to make way for the new, to bring good luck or to frighten evil spirits away. Fires, fireworks and gunfire were once common ways to celebrate the new year, especially in Appalachia.

The tradition of making resolutions or promises goes back to the Babylonians. One of their common resolutions was to return borrowed farm tools. Losing weight and quitting smoking must not have been high on the Babylonians' list of priorities.

Good luck has always been associated with the new year, or at least with the first activities that one undertook, such as gathering together on that day with family and friends. It was long believed that the first visitor in the house, so long as he was a tall, dark-haired man, would bring good luck. Eating certain foods—such as black-eyed peas, hog meat (pigs were a symbol of prosperity), rice and cabbage (it looks like money, and is also an accessible winter vegetable)—was believed to bring a prosperous year. Personally, I favor the old Dutch custom of eating donuts on New Year's Day, as the ring-shaped cake was believed to be lucky.

Then there is the new year's song, "Auld Lang Syne." While nobody ever seems to know the words or meaning, the song is sung at midnight on New Year's Eve in almost every English-speaking country in the world. "Auld Lang Syne," meaning "old long ago," is an old Scotch tune written in the 1700s. It bids farewell to the "good old days" and looks forward to happy times in the future.

So this new year, eat a little pig, sing a Scottish tune and make a Babylonian promise on the first day of a month the Romans named. But try to keep the gunfire to a minimum. Some of us like our New Year's calm and quiet, with a cup of steaming coffee and a fresh donut.

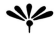

Onions, Horse Scabs and Other Home Remedies

When my mother was only a few months old, my grandmother did something strange to her: she pushed her off the side of a bed. Although such an act might sound like child abuse today, my grandmother was in no way trying to hurt her daughter. In fact, she had piled up pillows beside her bed to make sure my infant mother was not injured. She would eventually have three more baby girls, and all my mother's sisters were intentionally rolled off the side of the bed before they reached their first birthday. Mamaw once explained to me that her own mother had been a midwife in the early 1900s, and she had always been told that unless a child rolled off a bed before it was a year old, it would soon die. Mamaw, like her mother, was a bit of a superstitious woman.

Old cures and remedies once abounded in almost every household. Have you ever heard that placing a penny between your upper lip and your nose will cure a nosebleed? Or drinking chicken broth

made from a black hen will cure hiccups? Or that wearing a silver dime around your ankle will prevent poisoning? These and several other old-time superstitious folk remedies and charms are outlined in a 1962 "Lore and Legends" article by E.G. Rogers, published in the old *Athens Press*. Other cures for nosebleeds included looking into a glass of water or putting a pair of scissors down your back. Frostbite was said to be remedied by walking to a spring barefoot on three consecutive mornings, bathing your feet in the running water without speaking to anyone and never looking back once you begin. If a fever worm was seen, you were supposed to spit three times to avoid catching the affliction. Other hiccup remedies included nine swallows of water or spitting on a rock and then laying the rock spit-side down without looking at it. Carrying nutmeg in your pocket would cure constipation. Rheumatism could be treated by tying a woolen string around your waist, wrapping an old copper wire around your wrist, turning your shoes upside down under your bed or not speaking to anyone before bed.

Other cures were surely quite painful. Children with the croup were to make several slashes with a knife over the chest, cover each cut with a piece of paper and then place a cup of hot water over the paper. I suppose if the cuts didn't get you, the hot water would.

Still other remedies were simply disgusting by today's standards. Wearing a bruised onion tied around your neck would cure mumps, as did the less smelly act of carrying a potato in your pocket. The scab from a sore on the hind leg of a horse was to be given to a patient suffering from colic. To cure jaundice, nine eggs were hardboiled and strung around the neck. The intention was that in the morning the eggs would be yellow and the patient would be white. Earwax was supposed to cure fever blisters (I hope it was supposed to come from the same person's ear). Another cure for rheumatism was simply not to comb your hair for three days. I suppose that sufferers of rheumatism were easy to spot on the street by their hairstyle, and when they wouldn't speak to you before bed.

My grandmother lost much of her superstitious ways when she grew older, and her beliefs became more conversation topics than anything else. But she never allowed cats around babies (cats were believed to steal a baby's breath), she never walked over other people's graves and she believed that when a bird got in the house, someone was going to die.

Are such cures and superstitions still being observed today? Living in the twenty-first century, I'd like to say I'm not the least superstitious. But when two of my children developed severe cases of asthma, a neighbor cut notches on a willow stick that we hung over their bed. Another son developed warts on the bottom of his feet that did not respond to modern medicine, so we took him to a lady who could "charm" warts. In both cases of asthma and warts, the children were cured. But I think I'll draw the line at horse scabs.

The Hymn of the Slave Trader

John was born in England in 1725, and as a child he was raised by a deeply religious mother who tried to impart to her son the benefits of a faithful life. She taught him to read scripture by the age of four. But when he was seven, his mother passed away suddenly, and most of his education and religious influence died with her. After a few years of schooling, John went to sea with his sea captain father.

This first voyage seems to have had a great affect on young John. Watching the deck hands and captain pilot the ship over the seas seemed quite adventurous. As he grew older, he became a sea hand himself, and the nature of travel further distanced him from the moral influence of his mother. As the years went on, John lived as he wished, with little desire to be a very good person. Even after meeting a girl who seemed to have a good affect on him, his morals further degenerated when he was impressed into the Royal Navy in 1742.

The navy life did not appeal to him, and shortly thereafter John escaped in an effort to see his lady friend again. But he was soon captured, whipped and imprisoned, and it seemed he would be forced to serve at sea for a sentence of five long years. But a friend of his father's managed to have him transferred to another ship, and he soon found himself on the coast of Africa involved in the slave trade.

For the next few years, John continued to do as he pleased, and enjoyed corrupting not only his own morals but also those of the other sailors around him. He often drank, swore to the point he made up new words to swear by and was considered dangerous and distracting to the rest of the crew.

In March of 1748, his ship was returning to England when a severe storm stuck. Men were washed overboard and the ship was damaged almost beyond repair. Winds blew the ship far off course, and after several weeks all hope of rescue was lost. It was during this time, faced with certain death, that John began to lament his loss of the teachings of his mother so long ago. His hard living was no longer of much importance to him. Finally, the crew sick and almost starved, the ship made its way back to England.

The experience was not lost on John, who began to take a renewed interest in the lessons of his mother. He married his sweetheart and remained for a time in the slave trade, but his increasing interest in religion eventually forced him to seek other employment. He became a tides inspector, a form of customs official, in Liverpool, and published a book on the adventures that had changed his life. It was read by a man involved in the ministry who also wrote religious hymns, William Cowper.

Cowper and John became friends, and John became a minister in 1764. Around 1772, John wrote a song, a hymn that illustrated what he deemed was the fantastic power of the grace of God. For a man who was once a corrupt sailor and slave trader, this was a notable accomplishment.

John Newton's song, simple as it was, became popular almost immediately. It was published over and over down through the years

for over two centuries. It has been recorded in hundreds of languages and sung in every venue from religious services to sports events to rock concerts.

Knowing the history behind John Newton's song gives us insight into its words, as it has been sung in the churches and hills of East Tennessee since the time of its writing in 1772. It is the old gospel hymn that speaks of a wretched man, dying and lost at sea, seeking his salvation and his safety. It is known as "Amazing Grace."

Gray Faces and Few Words

I asked my late grandmother once about how she liked living in the good old days. She was a square-built woman, kind, but with a quiet wit. She wrinkled her small nose and shook her head at the question. "The good old days weren't good at all," she replied. "It's a lot easier living today."

She went on to tell me of times when catching pneumonia was a death sentence, when all cooking was done on a wood stove and involved the cutting, chopping and carrying of wood done almost exclusively by the children in the family. She talked about walking to school over a road that was little more than a wagon trail, and was alternately muddy, frozen or dusty depending upon the weather and the season. It didn't take me long to get the point.

Old photographs tell a similar tale. The faces in most black-and-white or tin-type pictures stare out with stone-like gazes, unsmiling, stiff and uncomfortable. Even the children are morose. I have often joked that with no makeup or deodorant, their stiff expressions betray their dislike of being so close to one another.

But for many of the people in these old photographs, it was one of the few, if not the only time they were ever photographed in their lives. Newspaper ads from the mid- to late 1800s indicate that photography

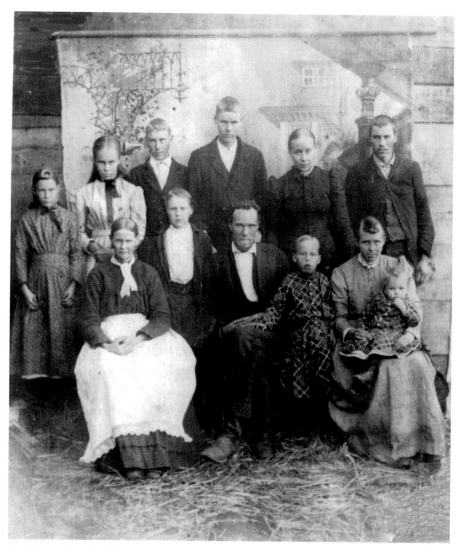

Families such as the Morgans, pictured here in Monroe County around 1890, were too busy working their farms to visit photographers in town, so when a traveling picture man passed through, the families cleaned up as best as they could. Such photos are now treasured by descendants. *Author's collection.*

was more of a traveling sideshow than the simple handheld cameras we take for granted today. Daguerreotype galleries would set up in local hotels in Athens for short periods of time, charging each person or family a fee to have their image taken. Even some of the early pictures of East Tennessee courthouses and downtowns were made by these men. Once they had captured and developed as many pictures as possible, the picture men would move on to the next town, promising their patrons to return again the next year.

Other more adventurous photographers would carry their bulky and expensive equipment on horseback or carriage into the rural areas, where travel to the towns simply for a photograph would have been considered a waste of good farming time. It is said that these door-to-door picture men would approach the woman of the house while her man was in the field, and convince her of the need to preserve the image of the likeness of her children, especially the new baby that might not survive the coming winter. After seeing some samples of his work, she would ply her husband for some form of currency to pay the man, whether it be room and board, some eggs, a bushel of fresh roasting ears or maybe some new horseshoes if the man had the skills of a blacksmith.

Dressing in their only set of good clothes, normally reserved only for the Sundays when the weather was good enough to make it to the church house, the family would wash and shave, primp and curl while the picture man would set up his curious box in the yard. But the cleaning only meant the face and hands, for children's feet, men's boots and ladies' skirts betrayed the dust and mud stains of their normal lives. The family would assemble in a group, as few could afford individual pictures of each family member. In chairs and on benches they would sit up straight and tall, summoning what dignity they could spare—children excited with the experience, the mother determined to get her memento, the father hoping for a quick end to the gallantry so he could return to his fields and the grandparents participating with the grudging opinion that such foolishness was bound to be a passing fad that would never catch on. The family would sit stone still as the picture man removed the cap from the box

or lit a primitive flash, and for all the time it took to prepare and assemble, the operation was over in a matter of moments.

The mother must have herded her children into the house as quickly as possible so as not to allow them to ruin their good shirts and dresses. Once changed back into their everyday linen, denim and muslin, all anxiously awaited to see the gray-tinted photograph that, when presented, was examined all evening long as a strange and mysterious thing and then placed with care in a Bible or box so it would not be damaged. It would lie there, only removed in times of recollection, when there would be a time and need to do so, until all of the faces were long grown old or passed away and the stiffly posed picture would become a hand-me-down or heirloom, or would simply be forgotten.

The picture man, with his buggy or saddlebags filled with whatever the farmer could spare in trade, would thank the woman kindly and move on to the next house over the hill, taking his time to prepare himself to make another sale to another skeptical country woman, not knowing he was catching bits of history that would have otherwise been lost to memory.

ABOUT THE AUTHOR

Joe D. Guy is a nationally published author, syndicated newspaper columnist, storyteller and historian from East Tennessee. Mr. Guy's popular syndicated newspaper column, "Beyond the Blue Line," published from 1999 to 2004, was drawn from stories he collected during his twelve-year career as a police officer, deputy sheriff, EMT, SWAT team commander and detective. Writers Club Press published a collection of the articles, *Beyond the Blue Line: Stories from the Other Side of Law Enforcement*, in 2002. Mr. Guy published *Beyond the Blue Line Volume 2*, his second collection of sixty-two stories, through PublishAmerica in 2005. His articles on school safety and officer-community relations issues have appeared in *Community Policing Exchange* and *Community Links*, and are widely recognized by school systems and law enforcement agencies across the country.

A student of history, Mr. Guy is also the author of the historical narrative *Indian Summer: The Siege and Fall of Fort Loudoun* (The Overmountain Press, 2001), which has received excellent reviews among newspapers, historical groups and tourism associations. Other historical articles have appeared in *Appalachian Life Magazine, Backwoodsman Magazine* and in *McMinn County: A History of Its People*. Mr. Guy was a 2000 and 2002 scholarship winner in both fiction and nonfiction at the Lost State Writers Conference in Greeneville, Tennessee. Since 2004, he has continued to write "Hidden History," a regional history column that continues to grow subscribers in several East Tennessee newspapers. In 2007, he published his first collection of this popular series in *The Hidden History of McMinn County, Tennessee* with The History Press, which won a 2007 Award of Merit from the East Tennessee Historical Society. This is his second collection with articles dealing with the East Tennessee region.

Currently, Mr. Guy is the assistant to the county mayor and county historian in McMinn County, Tennessee, where he resides with his wife and children.